Cabin on a Ridge

Cabin on a Ridge

by

Howard Simon

WITH ILLUSTRATIONS

Follett Publishing Company

Chicago • New York

Library of Congress Catalog Card Number: 69-10267

ISBN 0-695-80935-0 Trade

First Printing E

To Mina

Don't keep forever on a public road following after one another like a flock of sheep. Leave the beaten track occasionally and dive into the woods. Every time you do so, you will find something you have never seen before.

—ALEXANDER GRAHAM BELL

If civilized man's pursuits are not worthier than the savages, if he is employed the greater part of his life in obtaining the gross necessaries and comforts merely, why should he have a better dwelling than the former? I would rather sit on a pumpkin and have it all to myself than be crowded on a velvet cushion. I would rather ride on earth in an oxcart with a free circulation, than go to heaven in the fancy car of an excursion train and breathe a malaria.

—HENRY THOREAU in *Walden*

Foreword

1930 WAS AN unforgettable year. A bad
year. One-third of the nation was ill-housed and ill-fed,
as President Roosevelt said several years later. Some of
this one-third lived in tin shacks and cabins made of
packing crates along the Hudson River below River-
side Drive in the city of New York. I saw them as I
walked along the Drive, sketch pad in my hand.

Jobs were non-existent. Men were wearing clothes
that came originally from good shops but by now they
were barely wearable and these men were selling ap-
ples along the New York City streets. Life was hard

and uncertain. All segments of the richest society that man had known were bewildered and floundering. Our country was overpopulated in the urban areas, yet vast forests and farmlands with small or no populations lay neglected. Farm products were sold at below the cost of raising them. More banks failed each day.

Art at that moment was a luxury not many people could afford. Publishers produced few books, and these without illustrations. As a painter and book illustrator, I considered my condition. I wanted to go on making pictures for books, even if I could not do so where the best market had been. So I thought to search for a place where living was possible and money scarcely needed. The idea of working close to nature in an environment of green silent beauty, and uninhabited, for the most part, except by animals of the fields and forests, appealed to me.

Because of an early interest in pioneer life in America—I had already illustrated several books of the frontier—I knew about the Homestead Law of 1867. The possibility of finding out for myself the pattern of life in the sparsely-peopled hills of the Southwest presented itself strongly to my imagination. I never intended to spend the rest of my life there; even when I thought of it as a solution, it could only be a temporary one. Yet as it turned out, I spent the better part of five years there.

I made no great preparations for my mountain ad-

venture; the serious work involved in homesteading hardly played so important a part in my thoughts as the knowledge that I would have a remote place in which to think and work. What beckoned me most, I believe, was a completely new environment.

I loaded into my car everything I thought I would need for my work: canvas and paint, wood blocks and tools—the essential and innumerable things of my craft. I took along books, clothing and whatever garden tools I owned, these left over from a Connecticut farm summer.

In late spring I headed toward Arkansas and the Ozark Mountains. There were few states in which land could still be homesteaded under the federal law; Arkansas was one of these. It appealed because it was heavily forested, and in the hill country. What I had already learned of the mountain folk of the region interested me. It seemed they had not yet stepped into the twentieth century.

The trip in the car that brought me to Arkansas gave me an early view of mountain country that was similar to that of my future home. Four times my loaded car stopped overnight at tourist cabins. They were simple and bore little resemblance to the modern glittering motel with swimming pool and private bathroom complete. The places I stopped at were quite primitive, having outhouses and no hot water. Prices for overnight were fifty cents and, in the higher-priced

bracket, one dollar. At one dollar, a bath for general use was included. As I traveled leisurely through the Great Smokies, I observed the tiny farms nestled against the hillsides—impossibly steep slopes planted to corn. It was here I first heard the story that the mules that plowed this land had shorter legs on one side.

An outlander, such as myself, saw only the hazy beautiful mountain landscape—did not notice, too much, the wretched poverty of the mountain people working on their arid hillside farms, the women wearing sunbonnets, the men, black wool hats. The faces of both men and women were deeply lined, the skin stretched tight over high cheekbones.

As I rode through, azalea was in full brilliant bloom, as was rhododendron in the dark woods that lined the roads.

My tires began to give way under my load. Frequently there were stops to change and patch them. But finally I rolled into Little Rock, a lovely little city blazing with roses in May, and found the United States Land Office.

I had already corresponded with the United States Land Agent and he expected me.

"Here is the plat (map)," he said, and explained the requirements of the Homestead Law to me. It said, simply, one must live on the land for five years, (later the law required only three years), cultivate an eighth

of its acreage, fence one quarter, and build a habitable home. One was permitted to leave the land for five months of the year, but it would be necessary to report such absence to the forest ranger of the area. "Take the plat to the postmaster at Cove Valley," he said. "It is nearest the homestead, and he will find someone to help you run the lines of the land. It was surveyed in 1880, I think."

So I drove out the ninety miles or more across the mountains to Cove Valley. I found Uncle Zack, the postmaster.

Most of the things related here happened as told; some I may have heard and may have happened a little differently. Some annoyances seem too petty to mention, and are blurred, anyway. The quiet adventure of living a life in the woods, being aware of other life and growth about me, and using these sources for much of my work remains significant for me; its effects go deep and are unforgettable.

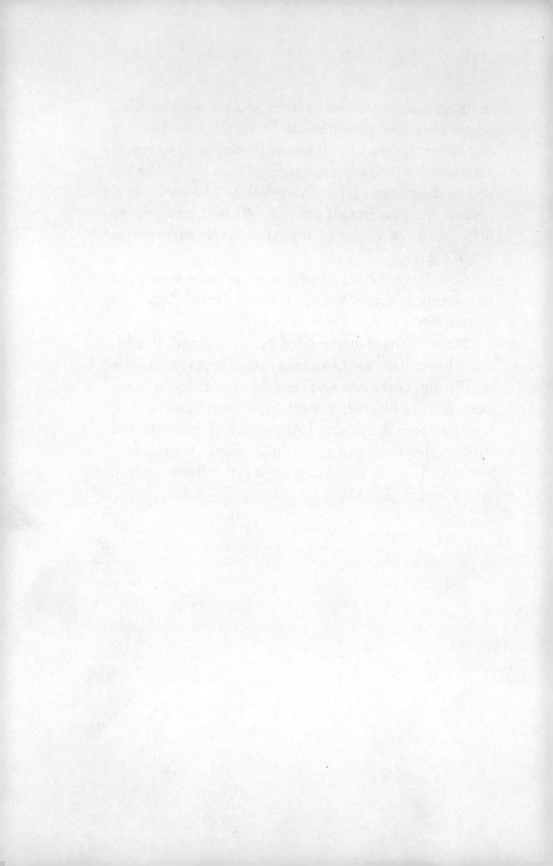

1.

He WAS a short thickset man in his sixties with a stubble of gray beard. He was dressed in well-worn World War I army breeches and a pair of artilleryman's leather-sided leggings over heavy boots. He was Zachariah Voss, Postmaster of Cove Valley.

Over the battered porch, supported by two-by-four posts, was a sign in faded black letters: *U.S. Post Office and Gen. Store*. This was Zack's home as well as the post office and his "Gen. Store." A line hung between the porch posts. Like clothes on washday, a

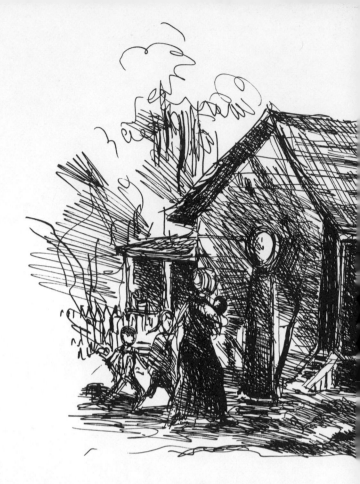

dozen raccoon tails hung on the line as a decora-
tion. On the porch walls were fox skins, drying and
stretched on boards. The whole structure, set on cor-
nerstones for a foundation, was made of boards with
barn weather-stripping over the cracks. The roof was
covered with handmade shingles.

It was a hot humid May day. I knew it was too
much to ask Zack to help me find the boundaries of
my homestead land, but I was certain I couldn't do it
by myself.

I took out my letter and map and with these in my hand said to him, "The Land Office told me you'd know, better than anyone else, where these hundred and sixty acres are."

He took the map from me and studied it.

"I know where they are," he said.

I continued to stand there, in the heat, waiting. I was not sure what I ought to say, so I said nothing.

After what seemed an endless pause, he walked with me out of the door and raising his hand, he said,

"Climb this mountain. It's near the top. There's a level place."

I continued to stand there, the doubt increasing that I could find my way in what I knew to be a wilderness.

I said, clearing my throat, "Would it be possible for you to come with me?"

Another long silence.

Then, at last, he said, "Spend the night. In the morning we'll go up."

I was filled with gratitude. I went inside again with him.

There were two rooms. The first was the store and post office. The stock in the store—I could see it all in a glance—consisted of overalls, some hickory shirts, a few tools, a double-bit ax, a couple of cross-cut saws, a coal-oil tank, its powerful smell overcoming all others, canned oysters, cases of Coca Cola, and, conspicuously, a lady's hat. Cherries surrounded its brim, and fly-specked veiling draped it. It must have been there for twenty years at least.

The second room was the one where Zack lived with his wife, Mary. The floors in both rooms were plank, scrubbed white with sand. In the dwelling part of the two rooms, there were a chest, two chairs and a table. Another chest stood at the foot of the large iron bedstead. These few furnishings and the stove crowded the small room. The counterpane on the bed was a

neatly-sewn patchwork quilt. The cast-iron stove was used for both heating and cooking, the flue going through the roof. The stove occupied almost all of one wall. The walls were papered with newspapers and magazine covers.

In most of the mountain cabins I saw later, there were almost identical furnishings.

We set out the next morning. We climbed up the mountain trail, over rocks and roots, until we reached a flat area covered by a stand of yellow pine with here and there a hickory or white oak left from an earlier time. We tramped the floor of the forest with its multitude of tiny pines, like grass, coming up through the thick brown pine needles.

Under a great white oak of immense girth, Zack pointed out three six-inch blazes, covered over by the tree's cambium layer. He used the double-bit ax he brought with him to lay bare a small section of the tree's heartwood, that part of the tree that is beneath the cambium layer. There were revealed the corner numbers and the survey date: 1878. So he had established the southwest corner noted upon the map.

Once this corner was established, it was not too difficult to find the direction by compass, and pace off to the next corner. But first, Zack and I sat under a leafy tree and ate the sandwiches his wife had prepared. They were made of biscuit and pork, and, for

dessert, we had fried pie, of which I was having my first taste.

We now had learned the boundary of one side of the homestead land. Old deeds often read "to a patch in wet ground" or "to a pile of stones" or even "to a turkey's nest in a dead pine." A marker might be "to a rich pine stump," that is, a stump full of rosin, for these last almost indefinitely.

My next corner did read: "a pile of stones." We found them. They were intact, and we followed the compass to the fourth and final corner. Without Zack's intimate knowledge of every turn in the trail, I could not have got very far in this first day of my homesteading. As it was, we were able to do most of the work of setting out my claim. It was evening when we went down the hill to Zack's house.

I lay awake on Zack's porch, that night, too tired to sleep. I was considering the strange place I had come to, and how this had come about, and at the same time listening to the night sounds; I could not yet identify them. I heard tremulous weird hooting and concluded it was an owl in a not-too-distant tree.

As a child I lived in a pleasant suburb and, later, in upper Manhattan in New York City. I felt no insecurity growing up in these places. I knew, however, by the time I was fifteen, and going down daily to the National Academy of Design that I would spend the

21

rest of my life in the almost certain poverty that was supposed to be the lot of a worker in the arts. I never did expect to make anything but a living at it, but I had decided to be a painter. I was unquestioning about taking the consequences, meaning the punishments, I had been warned about.

I spent two years at the Academy on West 109th Street. During this time I did some apprentice drawings for New York newspapers. I saved enough money

to take myself across the Atlantic on the *S.S. France* and celebrated my seventeenth birthday by myself in Paris. I lived and studied and worked there for the next five years.

I remember an evening around a table with Grant Wood and some other friends in the Latin Quarter cafe, the *Dome*. We talked about where we were heading in art. Grant said, "I've had enough of French Impressionism, enough of Paris. It doesn't seem to work for me. I am going back home, pick some small town in the west, and paint the people around me."

He did go back and somehow found his plan right for him and found wide acceptance too. Little of what he learned in Paris stuck to him. I think I never quite shook off the influence of the School of Paris. When I left Paris, Picasso, Braque, Matisse, and even Monet were still at work. Even more important for me was the impact of the Expressionists—Edvard Munch, Nolde, Marc, Kokoschka, and Max Beckmann.

I had read about the magnificence of the western wilderness of America and I had been more and more attracted to it, reading about James Catlin and Prince Maximilian; the German, Bodmer; and the pioneer diaries of Jedediah Smith and the others, and especially Francis Parkman's *The Oregon Trail*. I studied the drawings of both Catlin and Bodmer. I decided to drive to California on my return from Paris and settled into a studio in San Francisco. I continued to illustrate books that came my way and the pattern of the

working days in Paris were repeated in San Francisco. Painting now became as important to me as illustration and graphic work.

These experiences would hardly prepare me for the life I was planning for myself in the southern mountains of the United States, except that the stories of the westward expansion did stay with me, and here, I felt, I was about to share in the life of the pioneers, my forerunners.

I reviewed matters: I had had experience in my crafts. I was healthy, meaning I stayed well, which was not only desirable but a necessity for anyone undertaking a homestead.

I fell asleep, at last, although a strange new sound reverberated in the air, a soft whistling sound from the tops of the pines. The wind, no doubt, I thought.

2.

There WERE THREE steps I knew I must take to begin work on the homestead. First: the greatest need was for water, but to get the water to the house (when it would be built) there would have to be a cleared trail (the second step), and the beginnings of a road. The third step, or perhaps this should be first of all, was to acquire the tools without which I could not even begin.

I had brought along, in my Model A Ford, a small chest of carpenter's woodworking tools, part of my

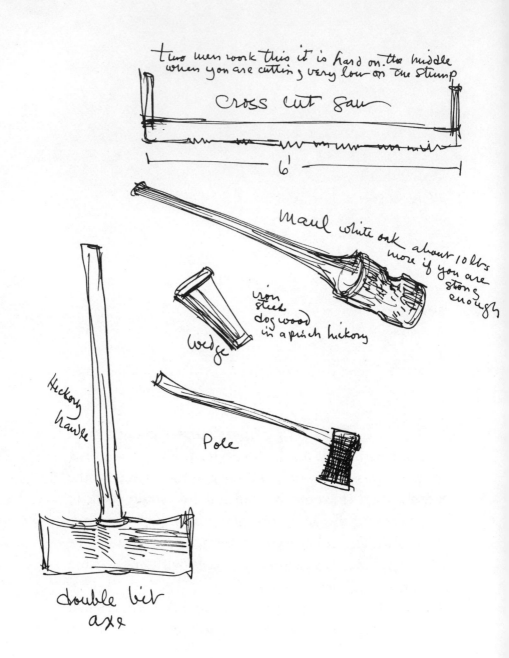

two men work this it is hard on the middle
when you are cutting very low on the stump

cross cut saw

6'

Maul white oak about 10 lbs
more if you are strong enough

iron
steel
dog wood
in a pinch hickory

wedge

Hickory
handle

Pole

double bit
axe

studio equipment. From Zack's store I supplemented these. At his suggestion I acquired a Kelly double-bit ax, a crosscut saw, a froe, spikes, and nails. Each of these was a necessity.

A mile or more from where I decided to build my cabin, I found a clear, cold spring. The overflow went across the trail in a slow trickle. I traced it back to its source among rocks, about a hundred yards from the side of the road. The water was too far to pipe, even if I could have acquired piping. It was near enough so I carried wooden kegs of water until I could dig a well. A sketchy path did exist, the deep ruts showing its direction up the mountain. It was once used as a trail for lawyers and mountain men on their way to the county seat when court was in session. It was still used occasionally by a mountain man in a democrat wagon pulled by a mule or two. I followed this trail since my Model A had a high center and could straddle the humps.

With one of Zack's sons as a helper, and using my new double-bit ax, we cleared the young growth out of the center of the road. Slowly I followed, driving a few hundred feet at a time, then clearing again until I reached the cabin site. I learned to use one blade of the ax for cutting close to the ground, keeping the other sharp for use on trees. After a week's work, a mile or so of the trail became serviceable. I brushed

my fenders against the trees now and then in the narrowest places, but I managed to haul a quantity of water.

Now the work of cutting the timbers for my house could begin. I learned to cut logs. Sawing with a crosscut saw is a two-man job. Zack told me about an excellent woodsman, Joe Loomis, who would help me.

I liked Joe, who was a quiet man with great strength and endurance. We peeled the bark from the logs with a hoe that was straightened so the edge could be pushed against the length of the log, parting long strips of bark from end to end. Then we let the logs dry where they lay, preparing to skid them to the house place. The cutting and choosing of the logs, about nine inches at the butt and sixteen to eighteen feet long, occupied much time. Careful selection made the final work, the fitting together, easier. We used only straight poles.

We came up the mountain to the home site each day, returning in the late evening when dark had already fallen on the little settlement of Cove Valley, where I had found a room to stay in. It was a seven-mile drive up the mountain to the homestead. It took almost two hours to get there, and about an hour to return. The warm dry season was beginning. I thought it best to camp on the homestead-site. It was primitive, but work went more quickly then. It was time, before too long, to skid the logs from where they lay peeled, to my cabin site.

At dusk one day, just as I was preparing to put aside my work for the day, I was startled to see approaching my lonely outpost, a man and a boy. Both were riding a single horse, the man in the saddle, the boy behind him holding on. As is the custom of the mountains, one I had at once acquired, I asked them to visit for a while.

After a lengthy conversational gambit—the weather conjectures, crop conditions, even long silences—the man came to the object of their visit: they wanted to dig a well for me close to the cabin. Fifty cents a day each was the pay they suggested. I hadn't any money to speak of, but it seemed little even to me.

They went to work the next day, digging the entire day. I had to be in the woods the whole time. While I was gone they left as suddenly as they had appeared, not even collecting their pay of fifty cents each, and even leaving their spades. I waited for a few days, then

went on with the job of digging the well. Joe, who had helped me cut the logs, relieved me at the digging too. His older brother also came to help.

I was curious about the original well diggers, and I asked Joe if he knew why they hadn't come back.

"The man's name is Will Allen," Joe said. "He has a still on Forked Mountain." The reason for Will's offer to dig my well, according to Joe, was that Will wanted to know for himself if I were a revenue agent. As soon as he had reassured himself as to this and learned I had come only to make pictures, he and his son left. They had no intention of digging a well for me.

The well had some water in it by the time it was down ten feet. I thought this was enough for my limited uses. So bathing and other facilities were possible, however crude.

My first three steps toward homesteading were accomplished. I was ready to build.

My nearest neighbor, an old red-bearded man named John Hatfield, lived about a mile away. He lived alone in a one-room cabin built of split and chamfered logs. The spaces between the logs were filled with clay. The plank door hung crazily on one hinge. The floor of his cabin was of pounded clay. An occasional weed raised its head indoors, through the clay floor.

When I walked down to his cabin one morning, it

surprised me to see, stuck out of an opening in the
wall—it wasn't actually a window—the head of a
jenny contemplatively chomping some brush.

I hallooed. Gun in hand, the old man came from behind the woodpile.

He knew who I was and we spoke about the weather, the woods, the crops, made all the usual introductory speeches. I came around to the object of my visit: would he help me place the logs on my home site?

He would.

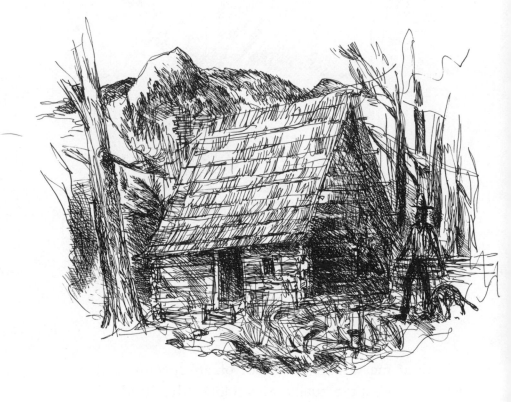

3.

He CAME the next morning. Astride the jenny I'd already observed, John Hatfield appeared. His long legs almost touched the ground. Behind him, he led a gray mule by the halter. These three were to be my companions for all the time the building went on.

To choose a large pine to make into shingles or boards requires something of instinct and skill. The woodsman puts his head close to the trunk and looks skyward to observe the tree for twisting bark or branches that would indicate the locking of wood

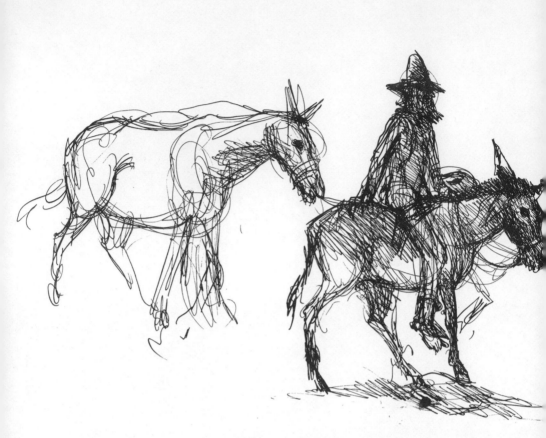

grain, or imperfections within the tree. With some experience it is possible to choose a tree that, after being cut down, will split quite perfectly with the ax and wedges, up to about five feet down from the first branch. Usually two- to three-foot sections can be cut with a saw, preparatory to splitting into eighths, as a pie is cut. Each of the eighths is then split by the froe into half inch boards and stacked in piles to dry. These make a roof with a beautiful texture that lasts well.

Cedar and oak are more durable than pine. Sometimes white oak is used, but it is much harder to split and handle.

Uncle John let me use his mule, and taught me a hitch for the butt end of the log. He with his jenny and I with the mule began skinning the peeled logs up to the homesite from where they lay in the woods.

It was hot slow work. At long last, the logs lay where I wanted them. We sorted them for size, working one at each end of the log, so there was not too much cutting to look forward to.

I heard about one of the mountain customs: John told me that many of the neighbors would come up for the house-raising. In one day the logs would be notched and then placed to the top, one upon the others. They would raise the ridgepole and put up the purlins, and I could finish when I was able to. He ended by saying it would be a good thing to have a few gallons of Mountain Dew when the men finished with the house-raising.

The news made me very happy. I was to discover that cooperation of this kind was common, was, in fact, a necessity. And not only in house-raising, but in many other needs such as chimney building, fencing, fire fighting.

In these ventures I cannot remember that money entered into the dealings, but tools and labor were exchanged. In the mountains, men took pride in their

ability to help with cooperative work, treating their individual skills with pride and vying with each other in these.

The Mountain Dew was not hard to obtain. I've already mentioned the Allen still.

Next morning I rode to Forked Mountain, got two gallons, then stopped at Uncle Zack's to get some coffee. I had been told the womenfolk would come along for the house-raising. They would come in wagons, John said, with the children, bringing flour and foodstuffs and quilts, too. The house-raising party would last through the night, and the guests would sleep in the wagons and under them, on the quilts.

I'd like to explain my own view of a troublesome impression held generally, even if I digress: the mountain people I knew were not the stock characters of the modern TV screen. The people I met were cut off from many of the faults of a civilization that seemed, then, to be teetering, for these were the Depression days, but also they were cut off from that civilization's benefits and advantages. They were, for the most part, independent and sturdy in spirit and body and, as in any community, had their share of evildoers and fools, but no greater share. There was in them an indigenous sense of humor and of the ridiculous, and a simple but not universally accepted form of religion.

Medicine, in this community, was non-existent. Preachers sometimes came by, when the crops in the lowlands were laid by. Customs were strongly entrenched and carried over from Scotch-Irish ancestors.

The country was sparsely settled and mainly under the Homestead Act of 1867. There were no large landowners, nor were there any rich people I knew of when I came to the community in which I was to make my home. Most mountain men owned their own homes, but some rented theirs. The largest nearby city was Little Rock, the state capital. It was over ninety miles away and constituted a different civilization, modern and urban, with the amenities of city living; its population was then 100,000.

The schools of the mountain region were the one-room kind. Already in the larger settlements in the towns there was the beginning move toward consolidation. This move had not yet reached Cove Valley.

The arts, too, were non-existent. Occasionally, away from my community, and in the lowlands, I met people whose intimate knowledge of the classics was great. They knew Shakespeare and Homer and the Bible. At evening gatherings I heard Elizabethan ballads sung. Also, they sang contemporary ballads, made up out of recent happenings, the voices high-pitched and thin. Some of the young people were so gifted that they were known outside their immediate communities as ballad singers. This was true, too, of fiddlers who played at the dances.

The Depression made no great change in the lives of the mountain people, it seemed to me. Money had always played a minor role. Most men had a gun and tools of a simple sort; others, the more affluent, had livestock, a mule or two, a cow, some chickens, a couple of hogs, and a tight house with a roof that didn't leak. They had, too, a small cornpatch, some grain, sorghum and sometimes wheat, and beans of every kind, in season.

On the best of their land the more enterprising grew a little cotton that was called "a cash crop." Most grew some tobacco for their pipes and "home-mades," meaning cigarettes. The white circle of a Bull Durham tobacco pouch hung from shirtpockets, more often than not.

At Uncle Zack's (everyone was called Uncle over the age of forty and under sixty; after sixty the title changed to Dad), in the early fall, a mill and press made sorghum grain into molasses. Some of this fermented into an alcoholic drink, strong—but not so strong as corn whisky, which was the favorite drink among the men. I have heard a good deal about Bourbon and branch water, but I knew no mountain man who diluted corn in that fashion. A man so drunk he could not stand was not common. For the most part this might happen to the young boys trying to prove themselves. Nor did I ever hear of anyone trying to explain away a drink on the ground it was medicinal.

Not long after break of day on a morning in early

June, the first wagonload of helpers arrived: Joe and his oldest boy, Ran, Marthy and all of her brood, including the new baby. Soon two men I had never seen before came on foot. They said nothing to me, but joined Joe and his family. Another wagonload, this time mostly men and one old lady, joined the crowd. Others appeared on the scene. Everyone for miles around was present in the clearing, busily preparing to take part in the house-raising.

4.

The WOMEN made fires on the ground, inside circles laid out in small stones, and they set about cooking.

The men looked over the logs and, beginning with the largest, began marking off with an ax the space for a notch. One at each end notched the logs.

They worked quickly. The first round of logs was soon laid on the stone corners about one foot above the ground. Then the second round, grooved to fit the notches, was prepared. As the rounds rose higher, the

men began to match their strength by lifting logs into place.

Before the last round was put on the cap of the structure, they nailed flat planks around the openings intended for windows and doors. These were spiked into place and the logs sawed even with the edge of the plank, cutting down through five or six logs with a cross-cut saw.

Then the cap was put into place. As the upper rounds grew too high to reach, two poles were placed at each end, about four feet in from the corners forming an angle with the building. The upper logs were then tied at each end, and the men pulled the ropes until the logs skidded into place. These upper rounds were notched in place by a man with some skill, seated astride the log. He held the ax short as he worked.

As evening fell, the last round was in place, and the crew joined in putting up the ridgepole and purlins. The rest of the evening was devoted to eating and

drinking. It was lively and gay. A boy sang a ballad, the men told tall hunting tales, described feats of strength. The fires burned down.

The sun came up early and hot, and the workers, wives, and children departed. My house was in the making. The walls had been built.

I went down the mountain to Uncle Zack's sawmill and steam engine with its belt-driven saw. Together we picked out some good unplaned boards for flooring and some slabs for the roof. A slab is an irregular pine board sawed at the mill from the side of a log, usually the first cut.

Zack lent me his democrat wagon, and I loaded it and drove his team of mules up the mountain. With my car it was a two-hour ride, but with the mules it took the better part of the day to get back.

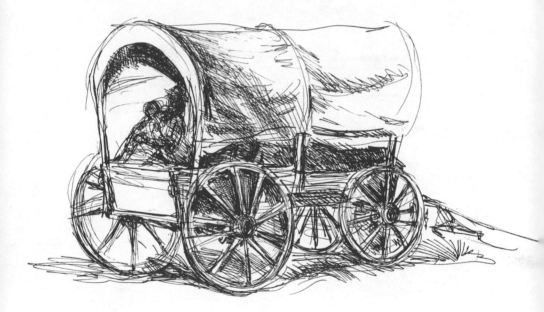

Zack had warned me to finish everything else before putting down the floor, and to stack the planks on a couple of logs to let them dry out before planing and nailing.

I nailed the green slabs to the purlins with air space between them, and it began to look like a finished house. By now I had a good many boards stacked and ready for use.

A board is about three feet long, and although it resembles a shingle and is nailed on the same way, it hasn't the taper characteristic of the shingle.

Joe and I began to nail the boards, one course at a time. In a couple of days the house was covered. I had been lucky. It hadn't rained until the roof was up.

Possibly Thoreau would not have approved of my desire to add a bit of art to what was essentially a shelter in the woods. Most of the mountain men would have agreed with him. I had a good many problems that faced most homesteaders, but the desire to decorate and carve and fashion out of the environment seemed to be mine alone. I now designed door hinges of carved oak and made a drawing of a mountain lion to carve out of oak as a decoration for my fireplace mantel, when I would have a fireplace. Immediately, however, I needed a studio in which to work, so I ordered a large window with sixteen panes of glass. The nearest place at which to get a window was Hot Springs, a long forty miles from my homestead.

Joe and his young daughter, Veona, came with me to load the window frames. The road was rough. We had to ford a stream before we came to the highway that was a good paved road going into Hot Springs. The first thirty miles were more suited to mule or horse traffic. It made an overnight trip of what was relatively a short distance.

The road was cut through virgin yellow pine forest, and there were few far views until one reached the top of a mountain. Suddenly an opening revealed a heart-lifting view. Not a house nor a settlement marred its splendor. We were looking at the preserve that was the Ouachita National Forest. The occasional 160 acres being homesteaded did not interrupt the grandeur and stillness of the forest. Yellow pine rises to sixty or more feet and the straight trunks move into the sky. The tops are covered with needles, but a branch is rare before thirty feet above the ground.

The forest floor is dark. Here and there a shaft of sunlight strikes through and illumines the tiny pine seedlings making their way toward the light.

Occasionally a white oak of great age and size may be discovered among the pines, and sometimes a hickory tree.

Hot Springs was, and still remains, a resort town and a luxurious one, and the paradox is that it was surrounded by untamed hill country, and the not distant unsophisticated mountain people. It had at least one

first class hotel, and others, less pretentious. There was a movie theater, perhaps two, and the other furnishings of a holiday and health resort. There was, at most times, a transient wealthy population moving in from the large northern cities.

The community in which I homesteaded was aware of Hot Springs, but rarely did mountain people find their way there, since everything was costly beyond their imaginings.

After these several months in the mountains, I felt rather ill-at-ease there myself, walking pavements and observing the people on the streets who looked like visitors from another planet.

A characteristic of my mountain neighbors was never to show surprise. I did not know until later and on the homeward trip that neither Joe nor Veona had ever seen an elevator. They had a look at one for the first time when they looked into the hotel lobby. Nor had they seen a motion picture before then. I showed them this wonder with pleasure, in the afternoon. It was a gangster film. Later, the little girl told her mother, "We went into a room and there were shadows, and they talked."

5.

With THE STUDIO window, my cabin was nearly complete. I would have to build a chimney and then I could have warmth as well as light.

Joe and I collected moderately flat stones. When we had a good pile, we dug a trench outside the cabin wall opening, which had been prepared to the dimensions of the fireplace. We filled the trench with a rough mixture of creek sand and concrete. This was the foundation. We laid rounds of stones, setting them in the concrete. By the time we were level with the floor of the cabin,

we began to lay the flat rocks for the hearth. When we reached a four-foot height, I placed a thick flattened log across the opening inside the cabin to make the mantel for my fireplace. Then Joe and his boy and I continued building the chimney straight up until it passed the peak of the roof by two feet.

Joe had built a scaffold, and the boy lifted the rocks up to Joe, who placed them. While they were completing the chimney, I carved a crouching panther on the flattened log that was the mantel. The panther was

long and lean and from head to tail made use of the log's full length. It was simplified in form, and I left most of the marks made by the fishtail gouge clearly visible in order to have the carving suit the rough interior of the cabin.

Early one morning I climbed up on the roof to flash the shingles around the chimney. I had only begun to work when I had to clamber down again, for I saw a buggy approaching, of the sort I'd previously seen only pictured.

It was black and had two high rubber-tired wheels and a black leather top.

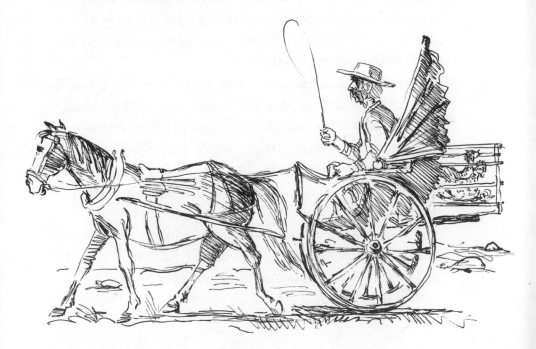

A tall white-haired man stepped down, tied up his horse at my gate, and greeted me. I asked him in. One is always glad to have company in the woods, and my greeting was, as usual, "Light and spend the night."

A doctor's satchel was in his hand. He wore a rumpled light-colored striped seersucker suit, somewhat grayed, and a small battered black wool hat. He looked considerably older at close view than when he got down from his buggy. He was probably seventy. The leathery skin hung loosely below high cheekbones. He was toothless, and he needed a shave.

We talked, as always, in a roundabout way, about the crops, hunting, whisky, horses, mules. He came indoors finally and, looking around my studio, carefully avoided any comment on what he saw there—pictures and graphic work in progress. His eyes lingered on the long shelves of my books.

He sighed, and said, "I'm getting older. I heard down the mountain at Zack's that you read a lot and you've come from outside. Thought perhaps you would like to be my helper. After a while take over from me. You probably know I am Doctor Miller. I drive from place to place, stay over with the sick, help with the bornings."

I had already heard that Doctor Miller knew a good deal of commonsense medicine, but had no license to practice. This was a community not even visited by the public health nurses who rode over much of the coun-

try farther to the north. Doctor Miller was very welcome everywhere and well thought of. People liked his stories. Besides, he often brought news of their relatives farther away in the hills. He took no money for his visits, but often was rewarded with a couple of chickens, sometimes a suckling pig.

The family where he stayed on each visit, gladly boarded him, and his horse, for as long as he stayed. This sometimes lasted a month.

The doctor showed me the contents of his bag; there were three pill bottles there. The green pills, he told me, were a specific for malaria. The white pills were for headaches. I do not remember the purpose of the pink ones.

I did not take up his offer of apprenticeship, but when he invited me to accompany him on a trip to the Morse house, where a baby was expected, I did go along with him.

We jogged along slowly in his buggy with its ancient gray swaybacked horse. When at last we came to the Morse house, we found the baby had arrived ahead of us. It was Thelma's seventh baby, and she needed no help or advice. She was already up and about, but there was another patient to be attended to, Thelma's mother-in-law, who was doing poorly and was confined to her bed. The doctor looked at her and shook his head. "I don't think she'll last until morning," he said. And he was almost right.

The doctor stayed through the night, and so did I, and the next day, toward evening, the old lady breathed her last.

The next morning, Thelma split the firewood, made the breakfast, cooked up hot bread and coffee, and fed the baby, who looked large, red, and healthy. Thelma was incredibly thin, with sticklike legs and arms, but apparently well able to do the hard household and outdoor work.

The men made a rude coffin of unplaned pine boards. When we had finished and the weird hammering sound had faded in the evening air, the coffin was brought into the house. The old lady was laid in it on a white linen sheet. Her daughter-in-law placed silver coins on her eyelids to keep them closed, and the singing of hymns began in reedy, thin voices. The room was lit by a single oil lamp that cast an eerie light on the corpse and the surroundings.

It was touching and strange to an outlander. I made a drawing of it later, showing the interior of the house, the one large room with its two double beds and a coffin on one of them.

All of the family including the children and grandchildren were about. When morning came, four of us went out into the field that had been made use of before as a family burial ground, and dug the grave.

The soil was dry and gravelly, and as one grew tired, another took his place. When the digging was

finished, one of the family nailed the top boards on the coffin. We carried it to the grave we had dug and lowered it into the ground, and we covered the coffin with earth.

Old man Morse, who was in his late seventies, had had no opportunity to learn to read. He had a strong religious bent, and he had memorized a large part of the Bible and was a strict Fundamentalist. He picked up the tattered Bible and spoke the words quite accurately. He spoke for a long time. The women cried aloud. It surprised me, for usually they were not given to showing their feelings.

When it was over, we went back to the house. Thelma and the other women busied themselves with the cooking for the large number of relatives and their children who had by now congregated.

The baby cried, and the children played noisily. In the yard an old Model T Ford without wheels served as a play area, and a rubber tire, hanging from a tree branch, was a swing.

Doctor Miller drove me home at last, inquired again whether I would care to be his assistant. I declined.

6.

On THE SIDE of the hill near Uncle Zack's store there stood a one-room schoolhouse. Mr. Jones, who lived on one of the nearby farms with his wife and seven or eight children, taught here. What he taught was simple and practical. He taught all grades in the same room, and at the same time: reading and writing and enough arithmetic for elementary needs.

If a child proved unusually bright—now and then one did—the boy or girl went on to a larger school where more advanced work was offered, staying with

relatives or friends of the family who lived in the neighborhood, and then went on to high school, but not many made the long trek to college. Few in Cove Valley took this giant step which seems such a natural one now for high school students.

Reading was not general. The reading matter that was available varied from the poorest of the pulp magazines to the classics, only occasionally known. Newspapers rarely found their way into the mountain country.

It was not easy for the large boys, who considered themselves men and did men's work, to sit next to ten-year-olds and find themselves struggling with similar problems. The older boys had probably never before had a school near enough to go to. Sometimes this discrepancy in ages created as great a problem for the teacher.

Once when the class of assorted sizes was out in the schoolyard for lunch recess, the teacher had some difficulty getting them all back indoors to their books. A tall husky 16-year-old, meaning to be helpful, yelled out at the other students, "Get back in there, or I'll whup you all."

Although this assortment of ages and sizes sounds primitive educationally, the fact is the school is as good as the teacher. "Mark Hopkins," it was long ago said, "on one end of a log and a student at the other adds up to a university education." And some of the teachers

were devoted and conscientious.

The books used were still the old McGuffey Readers, handed down from older generations. There were no libraries, but an occasional intrepid book salesman would find his way into the hills with Scott's *Ivanhoe*, Henty's historical novels, a joke book, Emerson's *Essays*, Longfellow's poetry. These books were generally sold for cash.

Some mountain families, like the Joneses, had purchased a number of books over the years for reading aloud.

The nearest approach to pictorial art was the arrival each year at fall of the portrait photographer. He came in a covered wagon drawn by a mule. Many mountain cabins had these portrait photographs on their walls. I never saw any other representations in

these cabins until my own pictures were hung there.

I did not have a radio, nor did anyone else living nearby. A single gasoline pump stood at Uncle Zack's store. The next gas pump was twenty miles away, at a crossroads where Jim Boggs lived with his sister. They also had the only radio I knew of in the mountain country.

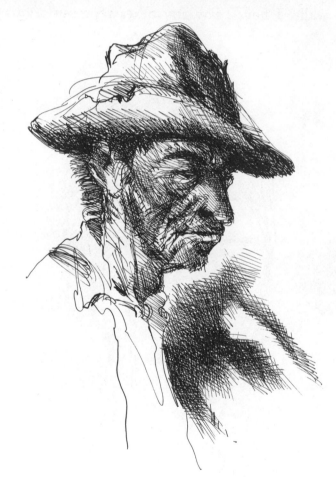

The materials of art, however, were close to me in my new environment and in the people themselves. After my years in Paris I felt myself starting again with these new-old elements. It seemed important to me to record my impressions.

To paint and draw the mountain people and to make murals of the indigenous subject matter, all of which I now hoped to do, was in a way returning to what had been done by Winslow Homer, Thomas Eakins, John Sloan, George Luks, and others of that earlier group, some of whom were still at work. Except for Homer, these American painters had confined themselves mainly to the cities for subject matter.

I thought then and still think that storytelling composition is not the answer for me, although much of my work is in illustration. More important, I feel, are mood and design, the surface of the canvas, exploration of new, personal techniques, and my own way of expressing myself in my medium.

During this early period of the homestead, I painted the family of Vander Hillary, his wife, baby, little girls, and two boys.

One of the boys, about twelve years old, took the greatest interest in what I was doing. He began to draw, too, using some of the materials he found in the studio. He could neither read nor write. He was a child who was more at home in the woods than anywhere else. He knew about the ways of rabbits and raccoons,

bobcats, and opossum. He was small, towheaded, and quick in his movements, and had bright blue eager eyes. His arms were thin, belying a strength that was considerable. His memory of the simplified shapes of animals seemed extraordinary to me. I noticed this when he was drawing a goat. He saw that the general shape—the impression—is triangular, and with a few lines made this clear.

In the early spring since it was still cold, he wore a coonskin cap without the usual tail. I painted him wearing this hat.

While painting Vander and his family, I had in mind Vander's essential quality—and it must have got into my portrait of him: his refusal to be involved in what was happening around him. Vander's reputation for avoiding a fight was known to most. Fights between adults were rare, but youngsters on Saturday nights would often end the dances in a free-for-all.

Through my studio window, one day, I saw a man on his hands and knees crawling down the road. Walking slowly behind him were a man and a large boy, whom I recognized as the Murphys. The man was carrying a rifle, obviously intent on threatening the one who was crawling. The man and the boy behind him did not look too serious about their intention and seemed to be exchanging jokes with each other.

There was no question about what they were up to:

running Vander out of the county on his hands and knees since he would not stand up and take a beating from the boy who was bigger and stronger than himself. They stopped to tell me about it: Vander had stolen a cow that belonged to them. It had been allowed to run in the woods, dry, as was the mountain custom. Its ears were cropped with the Murphy mark. The whole incident seemed far from funny to me but was apparently a source of humor for two out of the three participants.

I rarely heard a mountain man swear conventionally. They had a considerable vocabulary of invective in their own style. To call a man a "danged varmint," as the two Murphys now referred to Vander, was to invite a fight.

7.

I HAD BEEN interrupted in my chimney flashing by Doctor Miller. I had to go on with this, and asked Joe, who had promised to come to help me, but he was sick with "chills and fever." I was more and more aware that the ever-present "chills and fever"—malaria—was a major health problem. I tried to do something about this.

I'd noticed that the poorer the families, the likelier and more frequent their illnesses. Perhaps, because disease was so debilitating, work was only sporadic and so

they stayed poor. Also it was because they were so poorly fed, and diseases attacked the ill-nourished first of all.

I wrote a letter to our President, who was Herbert Hoover. In due time a letter on White House stationery came to Uncle Zack's post office. Uncle Zack sent his boy to tell me the letter was waiting for me. It occurred to me it would have been easier to send the letter with the boy, but then Uncle Zack could not possibly have known its contents.

When I reached the post office I did not hesitate to open the letter in Zack's presence, for I knew it would be as important to him and the other residents of Cove Valley as it was to me.

The note was a gracious one. The President, it said, had turned my letter over to Surgeon-General Parran, who would see to it that some practical help would be forthcoming. We all waited.

About a month later, toward the end of summer, a wood case arrived addressed to me. It came to Ola, the nearest railway station. A manifest was being held there, I was informed. I made hasty preparations to go to Ola, about thirty-five miles away over the mountains in the bottom land. Uncle John lent a jenny and a wagon, a wagon held together mainly by baling wire.

It is amazing to an outlander how much can be done with baling wire. My Ford was held together with

it, finally. Every sort of machinery from the old-fash-ioned steam engine to wood barrels was so held to-gether. Many of the young boys were highly inventive and very skillful with mechanical devices, and few owned even part of a car.

Bev Murphy was one of these gifted youngsters. Once when my car refused to go any longer, he spent a long time figuring out how to fix it. The clutch plate was worn smooth. To prevent its slipping, he cut a piece of old tire to fit and attached it to the plate. I was then able to drive it slowly to Hot Springs where a me-chanic fixed it properly, but Bev had reasoned this out. He had never owned a car and a Model A like mine was rare. The Model T was more familiar in the hills.

I was pleased when he rode by on his mule that day and suggested he would like to go along with us to Ola. He could hitch the mule and jenny together, and it would be easier to handle the large wood case this way.

We set out in the early morning, riding the bumpy wagon innocent of any springs. Uncle John had made hoops of hickory that were covered with a tarpaulin so that the democrat wagon had the appearance of a cov-ered wagon. Actually it was one, except it was smaller in size and had none of the fine workmanship of the Studebaker and the ships of the mountains and deserts.

The road was rocky and steep, no more than a trail down the mountain. A low rumble of thunder sounded in the distance, and a late summer storm was quickly

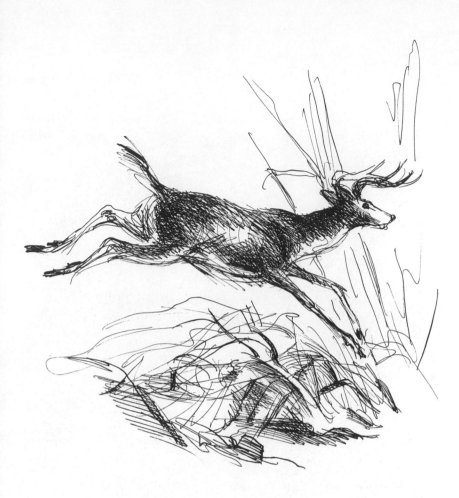

upon us. We heard a crashing sound through the brush
and saw a great white-tailed buck leap over the wagon
and disappear into the woods.

The storm furiously raged, and the sky was black
as night. There was an occasional flash of lightning,
and a roaring wind blew the torrential rain upon us.
We could hear the water pouring over the rocks at the

crossing. We got on the bed of the wagon under the leaking tarpaulin and waited.

In two hours it was over, and the sun came out hot and bright again. We could still hear the roaring of

Cove Creek, so we camped for the night, tied up the jenny and the mule, and ate the dinner we were fortunate to have taken with us. We were now a third of the way to Ola. I made a drawing of Rocky Crossing, later, and then a drypoint etching of the raging white water.

When morning came at last, the crossing was not unusual. We forded the stream, the mule and jenny managing their floundering way across. The wheels were almost submerged, but there was no mud at the bottom of the fording place. The ford was bumpy, but it was not too difficult to get across. We reached the bottomland and rode by large cotton plantations with an occasional field of tobacco.

The land was flat and bare of trees. A long way ahead we could see the town of Ola. It was one short street having a few stores with false fronts, meaning the front of the store seemed to be two stories tall, but a sideview revealed it was only one story high with the second story "false." The stores also had roofed porches. On each porch a few men were sleeping in the shade. The single street was a wide dusty road that looked exactly like a quickly manufactured movie set. The railroad track with a platform of wood to one side bisected the road.

Here and there a mule or horse was tied to a porch rail. It was hot and dusty. We went directly to the shanty that served as a station. Yes, the crate was waiting for me.

8.

I DON'T KNOW exactly what I expected to find, but I thought it might be medicine, a specific against malaria, with directions enclosed. I was not prepared for what I saw on opening the crate.

There was a top layer of pamphlets: *First Aid—Instructions until the Doctor Comes.*

The next layer was more of the same. All the way down to the bottom. The station man left us alone to decide what to do with our literature. We had at least one pamphlet for each person in the whole mountain

area, including those who could not read, and they were many.

We came to the conclusion that we would take the crate away from the station—a wood crate could be useful, and a handful of the pamphlets too. We loaded it on the wagon and we returned, thoughtfully, to the homestead.

When my house was livable, I went to work. I had plenty of subject matter. Almost everything around me suggested drawings and paintings. I had made drawings of animals but never before had I so many models.

There were cattle that ran in the woods, marked for ownership either by branding or ear cropping. All the mountain people understood that ownership was so established. There were razorbacked hogs in the hills, too, but I never saw them. The ones I did see were Poland China and well-fed looking. I learned that pigs love to wallow in water. If there is no mud in the water, they stay clean. They do not deserve their reputation for being dirty. They search for water and coolness, not mud.

The cattle that ran in the woods were dry cattle; they were allowed to forage for themselves, since corn and other grains were not raised in sufficient quantities to feed both the milking cows and the dry ones. To buy feed was out of the question. I never saw a silo on a mountain farm. On some of the burned-over forest

areas, wild grass grew. This and weeds were the cattle's main food supply.

An interesting—and fortunate—thing happened to me in connection with the wild cattle. One motley crowd of these animals ran in the woods near my homestead. In the herd were a couple of strange brown and white cows, their ancestry uncertain, skin stretched over their bones; a tiny gray jenny; a huge white steer; and tagging at the end, a small, perfect, black pony. It must have been foaled in the woods and lost its way from the mare. After coming across it several times, I concluded that, like the wild-running cattle, the little pony had no owner, since none of them bore a mark.

I really needed a horse. It would be more practical than the car and a great deal more fun, because I liked to ride. I had served some time in the field artillery of the National Guard and my discharge reads, "Horsemanship, Fair." At any rate, I learned to sit in the saddle and learned to ride bareback. It is interesting that almost every experience of my childhood and early youth has served me in one way or another.

One nice morning, the herd poked its way into my clearing, and I put a rope on the pony. It made no objection, but I was not so naive about horses as to believe it broken. About this time, Uncle John came along, and we made a corral out of pine posts. I borrowed a snaffle-bit from John and slipped the bit into her mouth. Her eyes started a bit, and I thought, now the trouble

begins! John and I took the old saddle and blanket, put them on the pony's back, and tightened the cinch strap around her middle. Still no bucking or jumping; just a quiet twitch, neck and head turned to see the queer goings-on. I grabbed the rein in my left hand, hoisted myself into the saddle, and rode slowly around the small corral. My preparations for disaster seemed ludicrous to us now, for Little Black (as I called her) had a lope, a slow trot, and a walk, was not fast but was dependable and companionable, and did instinctively all that was asked, so there was no period of training or breaking. Little Black stuck to the trail without any urging on my part.

The cattle in the mountains were mostly mixed. There were some Jerseys among them; they gave a much smaller supply of milk than those in the lowland, but they still had a relatively high cream content despite the lack of feed.

I had bought a cow and calf. She was a Jersey, but not much of a cow by dairy standards. Still they were healthy animals, and this was important, for the milk was not pasteurized. The cow gave me a quart of milk, sometimes, over what the calf needed, and a small quantity of cream was in the strippings.

Joe and I fenced off a small pen for the calf. I let the cow out to forage for itself on mountain grass. She returned each evening to her calf.

The wild cattle that ran in the woods and my own

cow and calf served me as models. I staked the calf out in the yard to make drawings of it. I was able to study the expressions of the calf, the way its eyes were set, and how it held its head and planted its feet firmly on the ground. I was able to see that each animal is an individual, with its individual characteristics.

My calf definitely had a will of its own. Once when I went to look for it, I saw it disappearing down the road. The little animal had managed somehow to escape from its pen. I chased it down the mountain and came close enough to rope it. Then I tried to tackle it and put the rope around its neck to lead it back. It was on the steep side of the mountain. I held on, tightly bound by the rope to the calf, and we rolled down the steep hillside together. I surely did not want to lose the decoy for my milk supply.

I can still hear the laughter from Joe, who was watching from the top. Laughing, he ran toward us to help. The calf was strong, and it took both of us to bring it back uphill to its home and mother.

Goats, I found, are enchanting animals, and the young ones especially charming and graceful. It is delightful to watch a kid standing on a stone or stump, perfectly balanced, its four feet well within the tiny area—perhaps eight or ten inches.

It was easy for me to observe goats and their young, for most of the mountain farmers kept them for their milk and the cheese made from the leftover

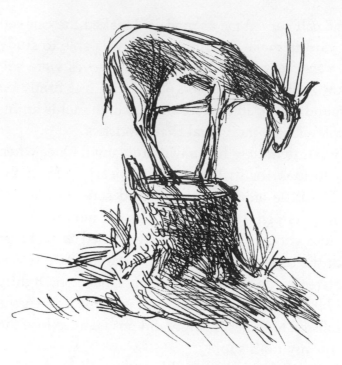

milk. Goats are thrifty animals, gentle and also independent.

Often I had chances to observe the wild animals too. A flash of a white-tailed deer leaping across a road leaves an emotional impact that one never receives from studying the same animal in the zoo. Both experiences are valuable, however, to an artist who wants more than a natural history description.

Of all the animals, the baby deer is almost pathetically trusting. I found one in the woods that followed me about like a puppy, the doe watching in the cover at

a safe distance. She had made a bed of pine boughs in the cover, where the fawn was born.

As soon as I went briskly away, the doe returned to the fawn.

Other animal life was abundant. Most of it was nocturnal, as anyone living in the woods would soon discover. Tracks in the dust of the road and unfamiliar night sounds told of a population greater than the one I'd made the acquaintance of, during the daytime.

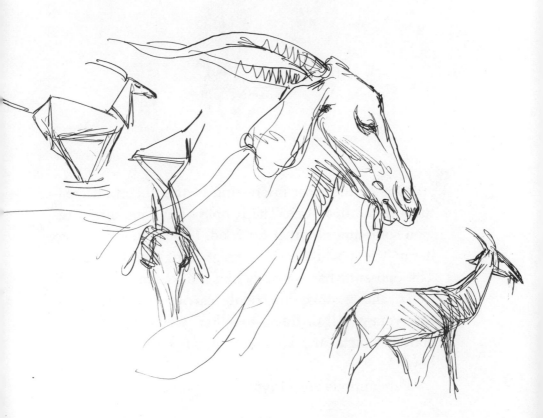

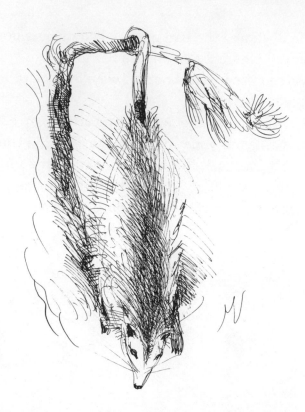

One of the most interesting of the nocturnal crea-
tures is the opossum. The people of the mountain re-
gion sometimes hunt it for food. I could never take to
it for it is a white stringy meat, tough and tasteless.
The opossum has a pouch like the kangaroo of Aus-
tralia, and in this the female carries about fourteen
tiny young. All of them, together, weigh less than an
ounce at birth and all fourteen can fit in a teaspoon
bowl.

Persimmons are a favorite of opossum and raccoon.

The persimmon is a slender bushlike tree found in cut-over land. It has glossy green leaves, and it is a hand-some sight when laden with its glowing orange fruit. Until quite ripe, after frost, these astringent fruits are scarcely edible, but after frost, if the opossums and raccoons don't dispose of them too quickly, they are a great favorite in the mountains.

One night, walking through the woods from a trip to Uncle Zack's, I surprised a bobcat by stepping on a dry stick. Over my head I heard the loud spitting hiss,

a magnified sound of the noise a housecat makes. Somehow it was not frightening. I had quickly learned that few of the forest beasts will attack unless cornered. This particular cat had the whole forest into which to disappear.

No one lives for long in the forest lands before he learns about the dread panther, or "painter" as he is called in the mountains.

Most of the tales one hears are folk stories and undiluted superstitions, but there is a real-enough danger. My first experience was with a panther I never caught sight of.

It happened on a trip to the settlement at Rogers. I was riding Little Black. I felt a bit embarrassed riding the pony since she was only about twelve or thirteen hands high. After the pony was saddled and mounted, my feet hung almost to the ground. Still riding down the mountain was more practical than riding down in my car. Little Black was strong and lively, and my weight was only about one hundred thirty-five pounds.

That day I pulled up at Joe's house, and we sat on the porch and talked. I'd brought with me as always some sheets of paper and a litho pencil and I was making a drawing of Joe whittling a twig.

One of his little girls came running from the barn, crying. There was a big yellow dog in the pen with the calves, she told us.

We hurried down. One of the calves was badly mutilated and dead, and the other was cowering in the corner. We must have frightened the panther away. We never did see it. We hurried back to the house for guns, and we were joined by others.

One of those who came along with us was a digni-fied white-bearded man who knew all about the pan-ther's habits. He brought with him a huge black dog on a lead. The dog agitatedly moved from side to side, fol-lowing an apparently clear scent. We were on the pan-ther's trail.

With concentrated effort, for most of the day, we kept up with the dog. Then the bearded owner of the dog noticed we were retracing our steps, going around in a large circle, and he told us it was a trick of the panther to do this. It now was trailing us. By nightfall we were exhausted.

We gave up and returned to Joe's house. I stayed there that night, listening to tall tales of panthers. Old man Bligh told a story I have heard many times, with only the settings varying.

Many years before, he had left his cabin and his wife and infant, to hunt at night. He had not been gone long before his wife heard a scratching on the roof near the chimney. The sound came through the mud plaster and wood framing, and bits of hard mud from the chinking fell into the fireplace. Courageously, and with great presence of mind, the woman built a fire in the fireplace. As the flames from the rich pine knots rose in the chimney, she said she could smell singed fur.

The scratchy noise ceased, but she stayed up all night with the baby in her arms and a loaded rifle on her knees. In the early morning Bligh returned with the

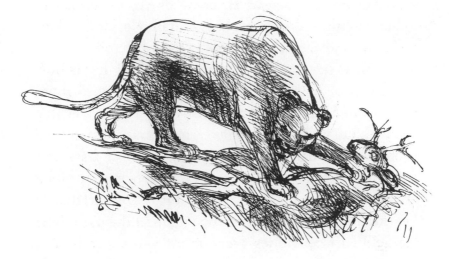

venison he had hunted. After he had hung it, she told him her tale. This time when he and some men went out in pursuit of the panther, they came back with its hide. Some of the fur, they noticed, was singed.

The idea that a nursing child attracts the panther reappears in these tales. Most mountain people believe this big cat will not harm a grown man, unless it is cornered. In all the tales I heard—and there were many—not one had to do with an attack on a man, but the results of its attack on a full-grown cow I have seen for myself.

The men of the mountains, in small groups, they sat on their haunches. Their frequent pastime was to spin a pocket knife and land it, blade down, in the earth. While so engaged, they exchanged tall tales of the hunt and now and then remembered stories of folk characters such as Jesse James. I soon participated in this limited form of entertainment, although I listened more than related tales from my own background. As this storytelling went on whenever mountain men met, I soon was familiar with the life and death of Jesse and the traitorous Howard. No mountain person ever called anyone by a last name so I felt a bit uncomfortable at hearing my name always as the villain in the piece. The Hatfield-McCoy stories were more varied, and since they had happened in a faraway place (Kentucky), were not real or exciting. They liked local tales even when aware of clear exaggerations. They laughed and poked fun at the narrator and never seemed to tire of the same stories.

9.

I KNEW no more of farming than I knew of forestry, so I began at the beginning to acquire farming skills. John Hatfield plowed a small field for me with a borrowed mule. He did a careful job of the plowing and, between us, with the aid of the jenny and a mule we removed most of the large stones.

The land had never before been plowed and was stony. There were stumps standing of the trees that had been cut for the house. John made a cultivator. It was constructed of three oak timbers joined to form a

triangle. The teeth were spikes driven in at six-inch intervals. Once again the jenny and the mule were at work, this time dragging the cultivator over the future garden. I got a load of well-rotted manure from Uncle John and spread it over the small field. The rocks that had been lifted out from the field edged it, like the beginning of a New England stone wall. I felt rather proud of my beanfield-to-be.

Most of the evenings I read and considered Thoreau's *Walden*, particularly the chapter on the beanfield. I think his philosophy underlay my farming altogether, for I planted only enough for my own needs.

Uncle John's theory was slightly different: it was to plant as much as you could so that if you couldn't use it all, the birds and beasts would share with you. If you didn't plant enough, they might take it all.

We never did get all the stones out, of course, but I found that a few stones broke the clay surface and helped to preserve the moisture—hence the expression, "poor man's fertilizer." All the same, it did not look like much of a garden, with its sprinkling of sizable stones.

The vegetables I planted besides beans, were a few rows of corn, bush beans instead of the pole beans that were more usual in the mountains, mustard greens, a few stalks of okra, onions, a few watermelon hills. So far I was among familiar friends, for I had had a small garden in Connecticut.

I waited for the seeds to sprout, and I hoed the weeds between the rows. The beans grew rapidly, but so did the weeds. With the anxiety and anticipation of the beginning gardener, I watered and cared for the plants, knowing they would help out with the food supply and cut down the number of trips to Uncle Zack's for supplies.

When the beans were beginning to blossom, I looked forward to the harvest. The corn was about knee-high, the weather hot and dry. Uncle John commented: "Hot nights make good corn." I waited for my crop.

One late summer evening a full moon shone over the garden. I wondered why I had awakened, then heard a thundering trampling sound. I went outside. A small herd of cattle were in the fenceless garden. The few stones around it were no barrier. I shouted and beat on a big pan, and they left at leisure, trotting down the road. I felt foolish and disheartened, for no

plant was left standing. I thought the growing season would be too short for a new seeding, but happily it wasn't. By the summer's end I had a garden again. This time I gathered a small harvest, for I had built a sapling fence, or most of one.

As I was working to complete the sapling fence, a man wearing an army campaign hat of 1916 and tall boots rode toward me. Without dismounting he called out, "I'm the wolf trapper. Have you seen any about? Any tracks hereabouts?"

The trapper was a hearty lean man with a three-day's beard on his tan-leather face. He reminded me of the marvelous portrait of "An Anonymous Old Man" by Memling in New York. His was almost the same bristly face.

No, I told him, I had not even realized there were still timber wolves in the forest lands. He said there were some, not many. He got no salary from the government, but there was a bounty of ten dollars for each skin brought in.

He dismounted and tied his horse to my new fence. After the manner of mountain men and at my invitation, he began to "visit" with me, meaning he stayed the night. We ate together. In the morning the trapper went on his way. It was a season of visitors. He had been gone only a little while when the forester's small truck came by.

Jim White was the United States forester. He lived

with his family in a white-painted house near Mountain Valley on the forestry station land. His job among many other tasks was to see that homesteaders fulfilled the requirements of the Homestead Act. The big lumber companies or other large land owners were

often suspected of putting proxies on the land as homesteaders, so defeating the purpose of the law.

The Homestead Act requirements were simple enough, to clear an eighth of the land, usually 160 acres in all, and to fence a quarter of these acres; to build a habitable house and to live on the homestead seven months of each year for five years.

Building my house had helped the first requirement, that of clearing some of the land, since I used many uniformly-sized pine poles, and these grew close together. I had much help in cutting the remaining ones to make the fenced field. After a year the field was cleared except for stumps. Gradually the road to the homestead was improved, too. Most of the larger movable rocks had been taken out, and the small new growing pines in the roadbed were cut to the ground. I could now drive my high-centered Ford over it without stopping to remove obstacles.

Incidentally, I learned what a prise pole was and how to use it. Inevitably my tires began to go. Joe was along once when I had a flat. There was a sheer drop at the side of the road. No jack could be used. Joe cut a pine pole about ten feet long and put a rock under the axle. Using the pole as a lever the car was lifted, easily, high enough so that it was possible to change a tire.

Jim White was satisfied with my progress and wrote out his report. He came each year thereafter un-

til my title to the land was established.

When he visited me in 1933, rumors had already begun to filter into Cove Valley about the new government in Washington. As Jim White was leaving, he mentioned the PWA, one of the first of a group of agencies I was to hear of for a long time to come. The initials stood for the Public Works Administration. Jim White said the Roosevelt administration had plans for this part of the country. He aroused my curiosity as to its aims. The next day I drove to Boggses' gas station over the main road, about thirty miles from my homestead.

I went the long way around so that I would not have the rocky stream crossing to negotiate. I took Route 7, the state highway, a wide red-clay road. Parts of it were graveled and built to an engineering standard until then unknown in the mountains. Almost the whole male population had worked on it at the pay of $1.50 per day, which seemed very good to the workers. It was a tough period for the state of Arkansas financially, and after a while the work ended, although much of the road was not yet finished.

As I rode along I thought of a man named Nolan, who had benefited from this state employment. He was a young father of perhaps twenty or twenty-one. He had two small towheaded children, and a wife a little younger than himself. They lived on a small farm that he rented on shares. He grew an acre of cotton and a

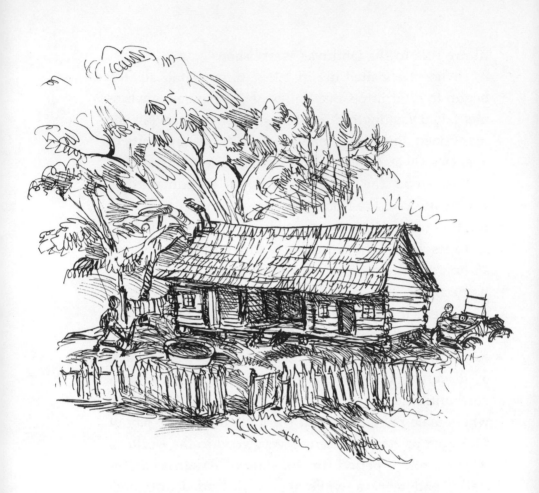

few rows of tobacco for home use, some garden beans,
black-eyed peas, okra, and watermelon. The landlord
furnished the mule, plow and house. None of the
sharecroppers' houses had even an outhouse for there
were the woods, close enough. Bathing was done in a
large zinc tub. When it wasn't in use, it was hung as a

kind of decoration on the porch. As a rule, the women kept these tubs scrupulously clean, washing them with creek bed sand, just as they used sand to scrub their plank floors.

Nolan's total cash income was on the average fifty dollars per year, after sharing with the landlord. He once said to me, "I sold my crop, paid my debt to the store in Ola (The store was also owned by the landlord), and I begged off enough to buy two new pairs of shoes for the young ones." He was not bitter about this, but he longed to own his own place. Yet in order to homestead, he would have had to own some tools, and to have enough money to keep him going during that first non-productive, building year.

To have worked a year and come out even was a usual matter. A good year was one in which a man could make a hundred dollars on tobacco and cotton. A poor one would find him in debt for necessities alone. Shoes for the children, new overalls, perhaps some yard goods for the women were the extent of their purchases. Even in fine bottom land, cotton was not paying. In the mountains, life was not too different from what it had always been. Not being so dependent on cash as the lowland people, and being accustomed to making and growing most of their necessities themselves, they hardly noticed the terrible pall that had settled over the rest of the country. In the cities people did starve, I had seen.

Nolan applied, one day, with some of the other men for a job on the state road. The road boss looked him over. His large powerful frame was a good recommendation, but the boss was skeptical.

"How can you work without shoes?" he asked, looking at Nolan's huge bare feet. Nolan, for an answer, raised his foot, struck a match on the sole and lighted a "homemade."

The boss said, "You'll do."

Nolan grabbed a spade and went to work. For the first time he was going to get a living wage and a chance to improve his long-standing moneyless condition.

In a little over two hours I was at the Boggses' place. I was in luck. The whole family of adults—there were no children—were crowded about the radio, a small box on the dining room table. They were absorbing every word they heard. I joined them. The reception from this radio was poor but it was contact with the outside world, something I needed and longed for.

The new President was speaking from the White House. In confident, well-modulated tones and Harvard articulation, foreign to this environment, he was explaining to his listeners—the whole country must have been listening—the direction we were going to take in the next four years. It held promise of a much brighter time.

The mountain people, for the most part, had always known poverty. They were fiercely individualistic, however, and proud. They accepted the new regime because, at least where I found myself, evidence of the government's good faith came almost at once.

I don't think there was a means test and there was no dole. People were given work if they wanted it. A guaranteed wage of thirty dollars a week was more than any of the men had ever dreamed of earning. People got work according to their skills, but there was no difference in their pay.

10.

I WENT home, considerably cheered. Shortly afterward, Mike Campbell, an engineer employed by the state came down the road to see me. I should point out that an occasional article or news report did appear that described my homestead and myself and my work. Also a friend would occasionally come out from Memphis or Little Rock to have a look at my strange existence. The whole idea of my homestead and my work there appealed to many people whom I did not know personally.

As a result of a news item in the Arkansas Democrat, Campbell, who had been appointed to supervise this small area, came with an offer. It was something I thought I could do with excitement and pleasure, for he suggested that I design an American Legion Building and paint a mural inside it. We talked for a long time. The government was to pay for the building. I was to get thirty dollars a week while I worked at the design and mural. All the other workers would be paid similarly.

I began work immediately. My design called for two adjoining rooms, each with a huge fireplace. Over one I planned on canvas an incident of World War I— a battle on land. Over the other, a sea battle of that war.

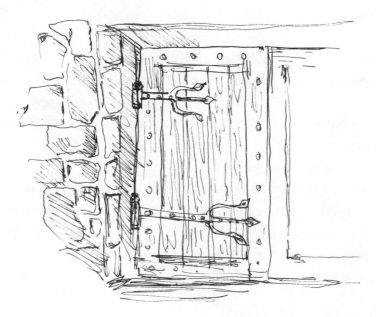

A half-timber building was indicated in my plans. It was to be of masonry, stone, and heavy oak timbers, and was to be built near the courthouse at the county seat. The doors were to be oak, and the ornamentation was to be hammered iron.

Since no one in these parts had done masonry of this sort, I agreed, out of my own limited knowledge in this field, to train a mountain friend who was a good mechanic, and another who was a blacksmith and good at forging iron, to do the iron decorations.

The blacksmith needed only to see the drawings in order to make handsome hinges.

To find a carpenter was an easy matter. The engineering and foundations were undertaken by Mike Campbell. The large trusses that strongly supported the roof were designed by him.

My friend the mason, newly titled and skilled, made the best whisky in the county. For a time he seemed likely to drink up his small profits. Once he went to work at masonry, the drinking stopped. The old battered wool hat was exchanged for a new one, Stetson style. His whole family shared in his position as a needed and able man.

Much nonsense has been spoken and written of the New Deal that relieved the desperate conditions of the Depression, many references made to leaning on a shovel, preferring the dole to work, and other such disparagements. I never saw a simpler proof of the state-

ment that if you give a man a job you give him self-respect than in the man I've described. It might be repeated for almost everyone in the community I knew. The ones I saw at work were happy in their jobs and

did their best possible for them. They transformed that part of the Ozarks in which I lived into a better place, and were able to feed their families, and for the first time in many years were out of debt to "the store." But everyone needed so much that no doubt the mountain people never did catch up with what would be considered the barest necessities.

Roads were built; fire trails put through—diminishing the huge damage possible from fire; even a small hospital was built as part of the Civilian Conservation Corps program.

This also meant an arrival of outlanders, and on a semi-military basis. But they came with shovels and trucks instead of guns. It was a novel sight to see the boys, in army fatigues and brimmed upturned twill

hats, cleaning up brush, as busy as ants, beginning and carrying through conservation measures.

I had not much contact with them. Occasionally I passed them at their work. They were doing much needed jobs. Most of them enjoyed their work, despite the hard labor in the heat. Part of what they earned was sent to their families in the cities from which they came. In the beginning there were plenty of blisters and sunburn among them, since they were city boys. They had few amusements, but a playing field was established and, once a week, a sound truck equipped with a movie screen and projector came to entertain them.

The CCC helped clear uncared-for forest and fought forest fires when they did occur. This is just to mention a few of the benefits the government programs brought. An occasional consolidated school came later too.

In an area as underpopulated as this one, the changes were at once visible. Of course there were stupidities and inequities in the execution of many plans, but it should be remembered that before this time, there was no effort whatever made to improve the conditions of existence.

My impression of the New Deal that was just beginning was slightly confused. It was probably confused even to those who were far more aware of its implications. For one thing, the mountain man, accustomed to being thrown on his own meager resources,

was skeptical of the federal government that had been associated in his mind with the draft of World War I, the revenue men, the far-off rumbling of a dire depression. This same government, composed of "foreigners" —outlanders and everyone not actually born in the hills community—was now coming to his aid. Even the lowland farmers and sharecroppers—except for their poverty—had almost nothing in common with the mountain people, and were also looked upon as outlanders.

11.

I HAD NOT yet finished fencing my home-
stead. I was still cutting logs, peeling them and then
splitting them into ten-foot lengths. John Hatfield was
helping with the rail-splitting one morning when a
strong smell of smoke came toward us on the breeze.
We saw smoke filtering through the trees and, carrying
a spade and an ax, ran in that direction.

It was a grass fire, not yet hot enough to ignite the
trees, but a light wind was fanning the flames. The
danger was evident.

We cut off pine branches about the size of a broom and began to beat out the grass fire. We were joined by two boys and a man unknown to either of us. As we beat at the edges of curling flames, the heat was almost unbearable. We were forced to spell each other. While one tried to catch a breath of fresh air, the other flailed away.

Luck was with us—and only luck. The wind suddenly shifted, and the flames receded. The danger was over. We made sure of this and saw that the embers had died out.

We lay panting on the ground, trying to recoup sufficient strength to go down the mountainside to the stream for a dip in the cold rapid waters of Cove Creek. There was always a small deep clear blue pool of water in the bed of Cove Creek. When we got down, we shed our scanty clothing and jumped into the pool. A few strokes across the water and we were refreshed. We put on our clothes and went home. We made a sketchy dinner that night of rabbit stew and coffee. I had kept the stew refrigerated, from last night's dinner, by lowering it, in a closed mason jar, into the cold water of my well.

As forest fires go, our little grass fire was hardly an example of the terror a forest fire can engender. We hadn't the equipment nor skill of the practiced forest fighters who contain and halt a fire that might cover as many as a thousand acres. Our experience had only

been enough to teach me a lesson in the hazards of fire
in the wilderness. To be aware of the frightened stir-
ring of animal life and its peril before the enveloping
flames, and to hear the crashing of the large beasts in
their attempt to escape, and feel the blast of heat and
see the red glow against the smoke-darkened sky are
experiences one can never forget.

Once I saw a glow like a blast furnace in operation, when I looked toward the cleft in Forked Mountain. The fire had been burning for four days and nights until a rainstorm put an end to it. As the rainwater quenched the fire, the hissing and cracking of branches could be heard a mile or more from the outer edge of the holocaust. Clouds of black smoke obscured the sun all day, and the air was filled with the acrid smell of burning.

Afterward the seared blackened scars were visible, strong weird shapes of the incinerated trees, sunrise and sunset glowing behind them in a kind of visual echo of glowing flames. Several hundred acres of forest were destroyed then. Probably in the next fifteen years the slash would be gone and the destruction softened by nature's progression and force. Then poplar would reforest the land, and the hardwoods—oak and hickory—would replace the yellow pine that had burned.

I've seen the instant change in a pine struck by lightning. Once, watching from the studio, I saw a bolt strike in the yard. Shattered bits of wood fell on the roof. Instantly the tree color changed from green to brown. Down the tree's side, a white bare streak ran to the ground.

Some of the lightning strikes seemed beneficial, paradoxically, for the pine sap was concentrated in large areas of the blackened wood and the resulting pieces when split were rich with rosin. "Rich pine" was easy to light without kindling. A splintered bit would start up with a single match. Everyone in the hills kept a pile of splintered rich pine to start the fireplace fire that burned with cooking heat.

Good meals were prepared in the embers of the hearth. When the fire was reduced to ashes, a hole was scooped out of the earthen hearth, and sweet potatoes laid there, the earth replaced over them, and then the still hot ashes and fire lasted nearly until morning.

When the sweet potatoes were uncovered, they were completely, deliciously cooked. I always considered this the best of the mountain foods, although I liked fried fruit pie and the many varieties of beans that were frequently in the menus. Hoecake, made of wheat flour, was another favorite. It was given its name because the dough was flattened on a hoe and the hoe stuck into the embers. When it was golden brown, it was ready to eat. Not that there weren't kitchen stoves, but some of the older people remembered the taste of the hoecakes made in the old-fashioned way of their childhood and liked it best.

The mention of kitchen stoves brings to mind Opal. He was one of Joe's boys. Marthy named him from the nameplate on her kitchen stove. "It's a pretty name," she said, and no one thought it strange for her son to be named after a stove.

12.

Nolan HAD WORKED a week. He was in a happy frame of mind when he came by my cabin. He was going to celebrate his job and to let his relatives know of his good fortune. Nolan and his family—the two-year-old, and the baby, too—were all going to visit twenty miles away in the mountains. I went along in his wagon. There was going to be a dance. When someone was giving a dance, the news traveled as inevitably as an Indian smoke signal. A dance was the most popular of mountain amusements—that and telling tall tales.

By the time we got there—it was in the deep woods on a small trail-like road—there were several wagons already there in the clearing, and an open Model T Ford without fenders, referred to as mudguards. There were about twenty adults, and a large number of children. At least half the adults were young people, mostly boys.

I had never seen a square dance. The caller of the dances, a thin, elderly, hugely-mustached man with a fiddle, called out the dance, and everyone took part, even the old men and women, stomping and clapping hands and twirling partners. Every so often a young man would cut loose from the dance pattern and follow the caller "cutting a shine," which amounts to a solo stomping and jigging at great speed. The mountain boys all wore their hair long and during a shine, their hair fell across their eyes picturesquely. I now discovered Nolan's dancing talent. He cut one of the wildest shines.

The fiddling went on through the night. At dark two lanterns of coal oil were lit; flickering light filled the crowded cabin. It had been completely cleared of its furnishings—even the iron double-bed was out in the yard along with a half dozen hickory chairs with cornshuck bottoms, as well as an infirm rocker. The walls, like most of the cabins not made of pole logs, were covered with old newspaper and magazine covers and the ever-present insurance calendar.

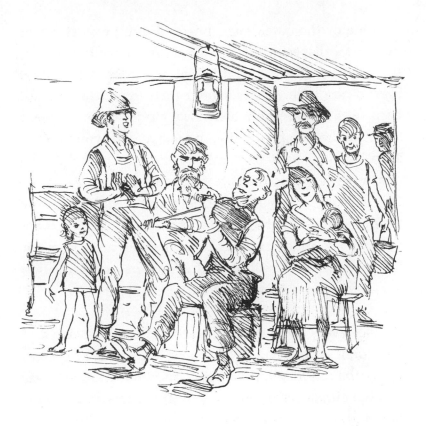

Behind the house stood the barn of unchinked pine poles. Barns, in the mountains, were no larger than the cabins, and differed from them mainly by not having chinking between the logs, so air circulated freely. The barn floor was tamped-down earth. In the rear and outside the barn, this evening, stood a rough table and on it was a barrel of whisky, a dipper, and glasses that were Mason jars without their lids.

One of the older men, bearded and gray, stood at the barrel dispensing the corn liquor. Prohibition was the law of the land, but this state was dry even before Prohibition. One of the young men invited me to the barn for a drink. The whisky was pretty strong. I went back to the cabin and the dancing. The young men soon had as much to drink as they could hold. The dance, with frequent visits to the barn on the part of the dancers, got noisier. The older people and the women left, and the young ones took over. Almost every dance ended in a fight among the young men for insults fancied or real, and this one was no exception —but there was no bloodshed.

Not every cabin in the Ouachita Forest consisted of one room. Some had two rooms and, in a rare case, more than two. None of the mountain cabins was painted either inside or out, but in the lowland or bottomland there were many painted, well-equipped homes even in small towns. All the same, unpainted houses have much to recommend them. The planks weather to a beautiful silvery lavender gray with brownish variations, and in sunlight, broken by moving leaf reflections, the color is beautiful. My own house that had three fair-sized rooms was at first the object of good-natured joking. One passerby spread the word that I had added my barn to my house and that he could see cows and pigs poking around inside.

Since the poles were not yet chinked he was probably believed.

After a few months, my house was accepted as an adequate design and, in time, an occasional reproduction of it could be found here and there on neighboring and faraway homesteads.

Thoreau goes rather elaborately into the great virtues of a one-room cabin. But it would not have been satisfactory for my needs. To explain my ample house, I was faced with the necessity of having a working studio. It meant having space and good light for long daylight use, since coal-oil lamps are not bright enough for engraving at night.

I had built long bookshelves in my studio, and the fireplace was drawing well. On cool evenings, I put crumpled newspapers under logs in the fireplace. One evening Uncle John, who happened to be visiting, reached into the set fire, stamped out the beginning licks of flame and said, "Never burn reading matter."

I did not know he could read. I was further surprised when he asked to borrow my *Walden*, printed in England, and illustrated with woodcuts by Eric Dalgleish. John was interested in the kind of book it was.

I recall one curious incident concerning Uncle John and reading. When I first came to the homestead, I enlisted his aid in cutting timber for my house. Once he was not at home when I needed him. I left a note asking if he would help me. The next day he came by

with the note in his hand. He said, "I don't read. Tell me what this says." I told him what was in the note, and he at once agreed to help me. I never did discover why deception was required. I can only guess that he simply did not want me to know anything whatever about him, including his ability to read. At least until he knew me better.

The name of Hatfield is legendary in the mountains, for the Hatfield-McCoy feuds were known to everyone in this isolated area. John never told me that he was even distantly related to the Kentucky clan of Hatfield. John was gentle and almost childlike in his wish to please, but he had a deep sense of what was right and plenty of courage when he needed it. He was respected by the community.

Once he came home to find there two young strangers, who must have come from a long distance away. He caught them taking off a young calf on a lead, the only calf John owned. He talked to them in his quiet way. One of the boys, however, threatened him with a club. John backed up to where his wagon stood. He had been loading rocks and clearing a piece of garden. He reached behind him and picked up a good-sized rock in each hand. He drew an arm back in the gesture of beginning to throw it.

When the boys saw he meant it, they began to run. John ran after them. They didn't dare turn around.

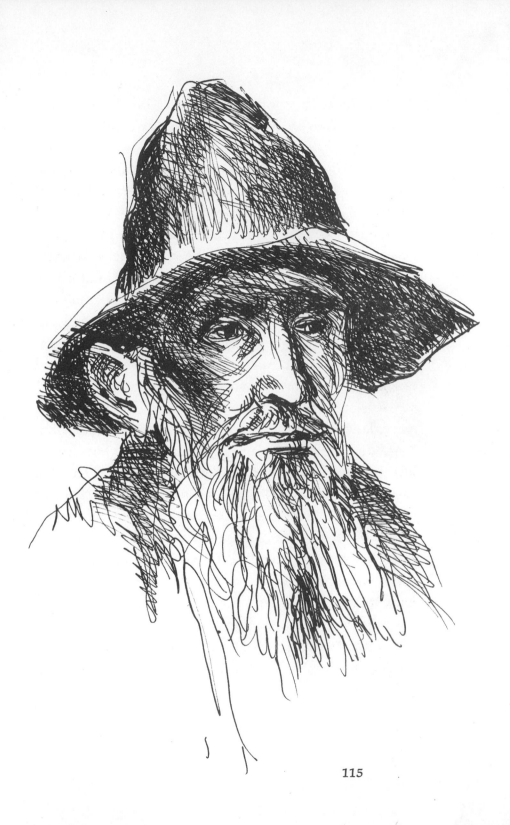

John went back to the cabin, put the calf in the pen and returned to his work. He was never troubled again so long as I lived there.

The story spread quickly over the valley and the boys, whose identity became known, were laughed at whenever it was told, wherever they appeared.

John never told me anything of his life in the past. I never asked. A man could come out to the wilderness for any one of a hundred reasons. I found him a pleasant, entertaining companion. That was good enough. I am sure I misjudged his age and considered him far older than he was. His slender, somewhat bent figure, his straggling beard of red mixed with gray, all seemed to belong to an elderly man, but he was probably forty, possibly forty-five. He was of medium height and not extremely strong for a mountain man. His eyes were bright, startlingly blue under heavy, somewhat drooping lids. His whole outward manner was easy to the point of seeming foolish to some of the men. I never heard of his having a sick day, although he lived on a diet that would not have sustained life for most. He rarely ate meat, for he disliked killing animals even for food. Sometimes when blueberries and blackberries were in season he would make a meal of these.

John had an interesting method of making butter. He used a Mason jar as a churn. Putting rich cream in the jar, he closed it tightly, and shook it hard. It took a great deal of shaking, but at last the butter would

form. Then John poured off the liquid and pressed the butter into shape. He kept it cool in the well, since neither he nor anyone else had any ice.

These impressions and happenings of those years when I homesteaded seemed then the least dramatic and most commonplace yet they remain with me and have gained importance. And these, too:

I remember at the top of the pines, against the sky, a red, somber, deepening glow of the departing sun as

it dropped behind the mountains and the constricting melancholy in me at that sight. . . . I remember my first taste of blackstrap molasses, strong, sourish, pungent. . . . The stinging-like tiny pinpricks on my skin when the sun was at its zenith, with everyone around seeking shelter from it under the trees or indoors, and remembering one young man who put his feet into a pail of cold water from the well and kept them there for the best part of the summer afternoon.

13.

As A GENERAL thing, the men of the
mountain country possessed two pairs of overalls, a
wellworn pair for everyday use and a clean pair for
Sundays and holidays, although Sunday was rarely set
aside for worship, for the religious life of the people
was seasonal. In the fall of the year when the crops
were laid by, for nearly a week most of the community
was involved in getting religion.

It was a serious matter, confined mainly to the old
people and the very young, who entered into it with
very great enthusiasm.

My community had its share of doubters and even an atheist whose ideas might have been based on Robert Ingersoll's views. His name was still associated with the devil in the minds of the religious.

The meetinghouse differed mainly from people's homes in the almost double height of the roof. The

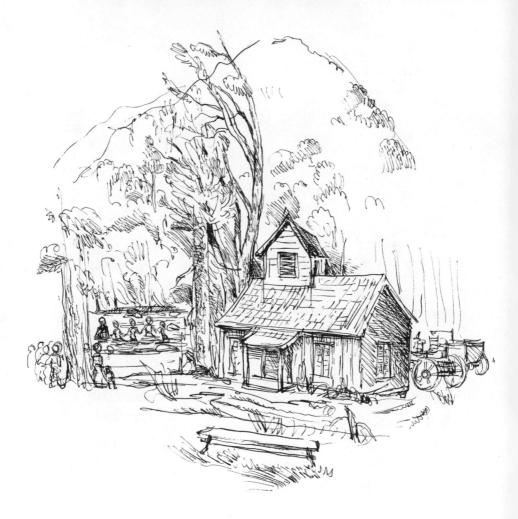

meetinghouse interior was filled with backless wood benches. A rude podium made of planks with a chair on them was up front. The two windows were small-paned. Trees and brush grew to the door. Behind the meetinghouse, Cove Creek flowed into a slow-moving wide basin bordered with sweet gum, hickory, honey-suckle, and azalea. It was a pleasant quiet place. Because of the sparseness of the population, only one un-organized church served the people, and the preacher was not a trained minister, but one of the farmers from the lowlands who felt the call and was able to lead the prayers and hymns. Baptism by total immersion was widespread.

On a sunny afternoon in October, people lined the banks of Cove Creek's basin. They sang

"In the sweet by and by,
 We shall meet on that beautiful shore . . ."

and the preacher led a group of sinners into the cold water of the creek.

Seeing my neighbors in this close relationship with their shepherd brought to mind one idea of Thoreau's, that seemed refuted, the individual's non-dependence on others.

The longer I lived in the mountains, the more I felt that cooperation was necessary and desirable. No one could exist without it, at least in my community. If I learned anything in the years of my homestead, it was that when a man lives by his own labors and lives far

from towns, he is dependent on others and is aware of this.

For instance, I asked John one day about raising chickens. He gave me helpful information. Nevertheless I doubt whether anyone knew less about chickens than I did the day I went to the post office to pick up a perforated box addressed to me from the Booth Farms in Missouri. The box contained a few dozen Barred Rock chicks with guaranteed bloodlines. From the time I first heard the scratching in the box until I reached the homestead, I was filled with a great uncertainty about their future.

I made a small coop for them, and put chicken wire around it. The coop had roosts and a complement of nests. The government had already prepared a pamphlet on the Raising and Care of Chickens that I had studied, hence the coop that had been prescribed. I had John's advice. With all the information acquired, I still felt inadequate to handle baby chicks. The meal I had bought at Uncle Zack's, however, was easy to feed them and, after a critical few days, it was a satisfaction to see them grow.

The United States Department of Agriculture has a worthwhile guide to nearly everything that is likely to occur on a homestead or farm. The cost of obtaining this excellent information was about ten cents per pamphlet. I gladly acknowledge that most of what I needed to know about cows, chickens, and garden feeding, not to mention fireplace construction and building came from these clearly written pamphlets. They contained true fatherly advice.

As the chicks grew larger, and became adults, a hen would occasionally steal out of the coop and nest under a bush near the fence. One hen was missing for about ten days. I had so few that by now I knew each one well.

One day I saw the missing hen. It crossed the path and I followed it to its nest under a shrub where it was setting on ten eggs.

While all this livestock did dig occasional worms

for themselves, the amount of food they were consuming was dismaying. All of it had to be brought in. Something had to be done about this enormous food consumption. I managed to trade all the roosters except two to Zack. I was pleased to be rid of them.

As I was looking into the nests for eggs one morning, I saw a large black king snake coiled in one. It left in a hurry, but it had disposed of the eggs I had counted on. The king snake is non-poisonous, and his presence usually means there are no rattlers in the neighborhood. It is generally thought in the mountains that the rattler, powerful and poisonous though it is, is no match for its deadly enemy, the king snake.

My cabin had been built on uneven ground and, at the back, stood two feet or so above the ground. One morning I heard the frightened clucking of chickens. I looked about and then under the house. I saw a little hen, transfixed, moving its head rhythmically, apparently following the movements of a snake's head. I chased the snake with a stick and pulled the chicken from under the house. It was clearly hypnotized and took an hour at least to return to its normal scratching and clucking.

No one was willing to take chances with the poisonous snakes. The mountain inhabitants went barefoot when they walked the roads, but when they went visiting or went into the woods, most of them wore boots or shoes.

Unlikely to make its presence known and as deadly as the rattler is the moccasin. It makes no warning sound as does the rattler. I saw moccasins swimming downstream in Cove Creek, moving their heads from side to side above water. The snake cannot strike below the water's surface so there is less danger if one is submerged, temporarily, that is.

The rattlesnake, although it does give warning, is still a formidable foe, should anyone be careless enough to disturb it.

Children and grownups on berry-picking trips must watch out for snakes. But it is rare that anyone on these expeditions is bitten as almost all such outings are accompanied by dogs—and dogs discourage snakes.

Rattlers vary greatly in size. Some are thick as a man's arm, three and a half to four feet long, with four, five, six or more rattles. Snakes do not hear, but they undoubtedly catch vibrations from the ground, since they move swiftly away from the pounding of horses' hoofs.

The berries of the woods are not all native. Some are escapes from long-abandoned homesteads. Not only are there berry patches but tangles of rosebushes, the old-fashioned red, and sometimes a pink one—the perfect "iron" rose. Peach trees and an apple tree or two, remains of an old fireplace, and a rusty pot—all speak of dwellers that once made their homes here and

then left. I never saw an abandoned well in any of these places, so apparently for the lack of water, a home place was abandoned. What interested me was

the way in which Nature took over, and man's work was all but obliterated not too long afterward.

Perhaps the inhabitants went away in order to settle in the Indian Territory opened to homesteaders in Oklahoma from 1889 on. Uncle Zack once told me he had been one of those who moved into the territory that was to become the state of Oklahoma. He found the lack of forest land and green-covered mountains not to his taste and, after a few years, returned to the Ozarks with his family. Probably all the good land had been preempted by 1903, the year he went out.

Zack told me he found it crowded and already there was a lack of the freedom of action he knew in his homeland. So he came back to the Ouachitas, settled in Cove Valley, brought up his family there and became postmaster, landowner, banker, farmer, woodsman, and made a little private liquor stock. He had cows, chickens, a sorghum mill, a flour mill and, with the aid of a pair of Sears Roebuck forceps, he also did primitive dentistry as an avocation. He had the only store for many miles around and in the community he was greatly respected. His younger son, Hebert, about 30, lived in a small board cottage on Zack's land with his wife and four small children.

I never passed the son's place without seeing a crowded clothesline, and his young wife boiling another kettleful in a large iron boiler over a coal fire. Hebert's young, rather handsome face was marred by

the lack of his front upper teeth. When Zack pulled. teeth, there were no replacements. His only palliative for a moderate toothache was whisky. A bad one always resulted in an extraction.

Of course, there was a licensed dentist in Hot Springs, but in my time I never knew anyone who went from Cove Valley to Hot Springs just for a licensed dentist.

14.

I WAS ENGAGED in setting up my etching press, a large old-fashioned one of the Star type with double handles made of iron bars attached to one of two rollers. Out of the misty rainy night, a visitor appeared, a man on horseback returning from the county seat to his home on Forked Mountain. His name was Floyd.

He told me that about a quarter of a mile down the road from my home place, his jogging horse stopped in its tracks, snorted and reared. He could not make his

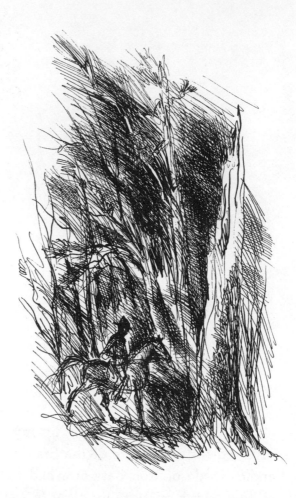

horse continue in the direction of his own house, so he turned about and ended up at my door.

I extended the usual invitation, and he did stay the night, tying his horse to my new fence post. Next morning it had cleared. I went with him to discover, if possible, the cause of the horse's fright. We walked our

horses down the quarter of a mile. To the right, a short distance from the road, and in our full view, was the mutilated carcass of a yearling calf. There could be no mistaking the marauder. Great gashes near the neck nearly severed the head from the body, and the thrashing about of the doomed calf left debris for ten feet. It was a horrible sight. As I left Floyd to go home, I remembered again the stories of the panther's enormous strength. I had just seen evidence of its awful power.

The panther ranges over most of the wilderness area still left in North America, but its ranks are depleted as the wilderness shrinks. Even where it exists it is rare for a person to see one in its natural environment. When fully grown, it is tawny yellow—the kittens are spotted. Those who have heard its cry say it

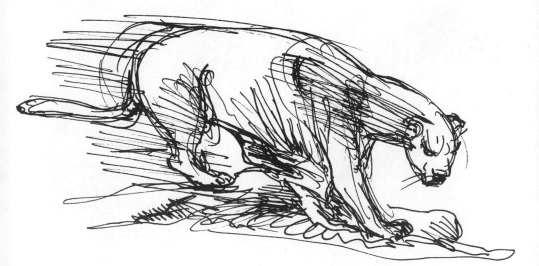

sounds like a human scream of terror. It springs noise-
lessly downward, most often from the strong branch of
a tree, where it has concealed itself among the leaves.
Most of the animals who are its prey seem to sense its
presence and often are paralyzed by fright. Dogs will
track the panther, but even in packs do not dare to
come close. After the kill, buzzards may be seen wheel-
ing overhead. Looking at the sky, I knew that as soon
as I had left the scene of the struggle, not much of the
calf would remain.

I knew a man who had a huge black wolflike dog.
The dog had once made an almost fatal error and tan-
gled with a treed panther. By the time the dog's owner
had killed the beast with a rifle, the dog was badly

clawed. This was long before I came to the mountains, but the great scars were still clearly to be seen on the dog's back.

I returned to my house and the setting up of my press. Between the rollers, a metal press bed covered with blankets held the dampened inked etched plate against the paper. A simple boxlike table made an adequate base for it. I made a number of drypoints at this time and printed small editions of four or five prints of each that I hoped to sell. The woodcuts I made I printed in the Japanese fashion, rolling the ink on the plates, laying the paper on the wet ink and burnishing the back. This was a slow process, and I could make only a few prints from each plate.

Some time after I had set up the press, I had to leave the cabin for a few weeks. I informed the forester of my proposed absence, since that was the rule. Just as I was leaving, a federal officer appeared. He came straight to the point:

What was I planning to do with my press while I was gone?

"Leave it where it is," I said.

"We'd better carry it to the county seat and lock it up in the jail," he insisted. "You know this is the same type press that counterfeiters use. It's best not to leave it around." So we took it to jail where it served time until I got back.

My journey was to take me to Memphis to paint a portrait. Aside from the excitement of painting a portrait of someone who greatly interested me, I must admit I looked forward to a change from mountain diet. The latter was adequate, and some foods exceptionally good, as I have said. What was absent was variety and "store" food. Canned oysters were the great treat for a mountain family, as were coffee and sugar. White flour was another luxury. Homeground cornmeal could be purchased at Uncle Zack's mill, where a steam engine powered a belt that turned the millstones. The stoneground cornmeal had an especially good taste, and it made good corn bread and cornmeal mush. I don't remember ever seeing an overweight mountain man or woman, but neither did I see anyone starve. Almost every family had plenty of meat, due mainly to hunting skills.

I painted the portrait. The good offices of a friend had resulted in getting me the commission to paint a federal judge. The judge was a man of farflung interests; one of these was his great admiration and knowledge of Louis XI of France. He knew every facet of his life and his enthusiasm made the king come alive for me. I was particularly interested in the historic period because I had illustrated in woodcut, not long before, "The Ballads of François Villon" published by the Limited Editions Club. My portrait sitter illuminated much

of the time in which Villon lived, the reign of Louis XI.

It is always helpful to have a sitter who is conversational and animated, and the judge helped me enormously, for his face was alight with his involvement in his subject. I thought the portrait a good likeness and a good painting.

The judge's wife did not see the painting in progress, nor did she see it when it was finished, for she was then traveling in Europe. It was to be the judge's gift to her to celebrate her return.

He was an enormous man, weighing at least three hundred pounds, very tall, impressive, and bald as an eagle. In his robes, as I painted him full length, he looked even more impressive.

His wife was fairly young and charming. Her pleasant manner toward me, when she came home at last, hardly prepared me for what followed. When she saw the portrait, her face fell. On the piano, in their elaborate French drawing-room, was a silver-framed photograph of a young and handsome Captain of the A.E.F., the judge, about seventeen years before.

"I had hoped you would paint him as he looked then," she said unhappily.

A week or so later, the judge asked me to come to his chambers. When I arrived, he said, "I am sorry, but my wife will not hang your portrait in our house. If you want it, you may keep it."

I felt sorry for all of us, and I accepted his check regretfully. When transporting the portrait to New York City, it was lost somehow, among other paintings I could never find. I would like to have seen it today.

15.

Fall WAS APPROACHING. In autumn the rains began and a change took place in the lives of the people of the mountains. Rocky Crossing was impassable.

All the way to Hot Springs, the creeks became too high to cross by car, nor were they passable by horse-drawn wagon, for the creek was higher than the wagon beds. From the homestead I could hear the roaring of Cove Creek as it rushed over its rocks. Only one bridge crossed Cove Creek on the main road, and that was some miles from my place.

The main road was two lanes wide, covered with red clay over which there was a thin coating of gravel. This time of year it was muddy and slippery. I used it as little as possible. My last ride of one fall season to Uncle Zack's is one I remember very well. Nolan was riding in the open rumble seat of my Ford. We slithered through the mud down the mountains at a very slow rate. Alternately the road was red clay that oozed

up to my hubcaps, or it was slick and smooth. In my rear-view mirror I could see that Nolan had one leg hanging out of the car, ready to jump if the car should leave the road. I have seen mountain men do the same thing when in a Model T without brakes. Since it was rare to meet another car on the road, the drive was not so dangerous as it sounds, but it did signify the end of the visiting season.

I began to spend more and more hours in my studio. I found my experiences were beginning to coalesce, the pictorial material becoming clear. I now began a series of wood engravings of the people and life of the mountains. Many of my friends and neighbors found their way into this series of engravings.

One of the engravings, a family study, was selected for the graphic section in the World's Fair Exhibition in Chicago. I later made a large painting of the same composition that was exhibited in Little Rock and, later, in New York City. It is a painting of Vander and most of his family, grouped in the breezeway of their house. In the background is Forked Mountain.

I meant not to make this painting a sociological comment, simply intending it as a family portrait, but it was not well received in Little Rock. In New York, my dealer at the Clayton Gallery told me it had caused much favorable comment on East 57th Street. It was never sold, and it is in my studio bringing to the Berkshires a pictorial memory of the Ozarks.

There was hardly a mountain cabin for many miles around that did not have one or more of my drawings. I drew Joe Loomis and his family and gave the drawing to them. The next week a wagonload of his relatives arrived "to spend the night." Soon the major reason for their visit was made known: they would like me to draw their pictures and would trade something for them.

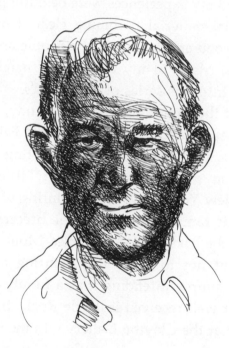

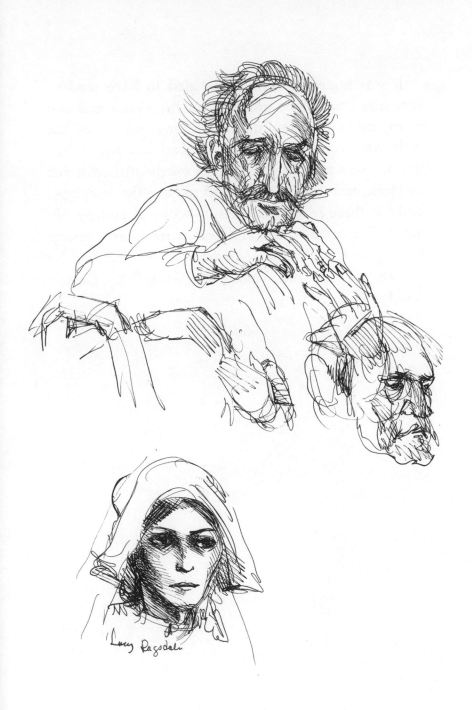

Lucy Ragsdale

It was honest barter. I was glad to have models. Generally I made one drawing for my sitters and one for myself. Every Saturday for a long time, until the roads were completely closed by bad weather, I had sitters. I was profiting by having excellent models for my work, and they were pleased to have the drawings. Many of these served me well in books of pioneer life that I illustrated—then and for years later. Among these were *The Diary of Jedediah Smith*, *Old Hell* by Emmett Gowan, and *Young Buffalo Bill* by George Gowdy.

16.

The WINTERS at the homestead were long ones, but broken by stays in Memphis and Little Rock. These visits helped establish me in both those cities and, even better, resulted in some lifelong friendships.

Before I left, I always notified the forester, in accordance with the Homestead law. By this time no one thought of me as anything but a bona fide homesteader, since my money affairs were not more complex than the natives. This equality of poverty was not strictly true, for I had some resources not available to

them. During my homestead years, for example, I was being paid for illustrating books sent me by publishers. The fees for illustration in the thirties were small, and when I sold a print outside the mountains, the price was never more than twenty-five dollars and often less, but it did happen occasionally that a collector would buy a print or two. Of course I had to buy materials and canvas and often several reference books.

The Ballads of François Villon was commissioned while I still lived up north and was finished before I went down to the homestead. Later, in the course of printing the book, and after I had come down to the homestead, it was necessary to add two engravings. This led to correspondence with the publisher who, at length, asked me to come to New York to sign the colophon sheets, offering to pay the railroad fare—one way.

I came up and autographed the books. For three weeks I enjoyed the company of old friends and walked familiar streets.

On my return to my mountain cabin, I remembered the comfort of an upholstered armchair, and I made a wingchair with arms. It wasn't really comfortable, but it looked good enough. After a while I made a trestle table and benches, and an openshelf cupboard, all these of rough pine from Zack's sawmill.

Following his own peculiar code, a mountain man will not show surprise at anything. It does not mean

there is a lack of interest. Nolan came to see me, and he examined the armchair.

"I'll trade you two days' work for it," he said.

I gladly agreed. Next day he came, and we worked together splitting fence rails. I not only got two days' work from him, but learned how to use a pair of wedges to split pine poles into quarters, and then they

were set down wormfashion. This method is now hardly used, for it is lavish in the use of wood. There was plenty of it about, however, and it had little commercial value.

We made a couple of mauls of white oak to drive the metal wedges, and also made a few dogwood wedges. Dogwood is a close-grained wood and takes punishment without splitting. A maul weighed about ten or fifteen pounds or perhaps more. After a long day's work, one is aware how heavy it is. The logs have to be chosen carefully, since any twisting in the grain makes it difficult to split. Pine is the poorest of woods for fencing, since it rots in a few years and must be replaced, but it was the easiest to find and split.

We were sawing with a cross-cut saw when I saw a strange look on Nolan's face. The object of his worried scrutiny was on my shoulder: a large black tarantula.

Mountain men consider the bite of the tarantula fatally poisonous. It may well be true, but this one did not bite me. I cast it off. I have since heard that the tarantula's bite is not so serious as annoying, but I am glad I did not have to prove this.

Centipedes are more common than tarantulas and not too bothersome, except that occasionally one would hurry across the beams in my studio and fall upon my plate while I was having dinner—as unpalatable an addition to a dinner plate as one is likely to see. They grow to large size, at least six inches long, and are not

147

easy to do away with. Tradition has it that the scratches of its claws cause infections.

Dangerous or not, the red centipedes are unpleasant dinner companions. This much I can vouch for out of my experience.

Among the pests that one must contend with in the southern mountains are chiggers, tiny mites that bite in inverse proportion to their size. Another adversary is the tick, the scourge of cattle and people alike. The cattle have a little advantage over people, because cattle can be dipped and so be rid of ticks. The mountain people were aware of this method of ridding the animals of ticks. Often, however, because of the cost and labor of handling the pit for the dipping, nothing was done to relieve the unfortunate animals.

Wood creatures and insects provided much of the subject matter of another neighbor, old man Bligh. He was an intrepid and famous hunter in my part of the woods. He was tall, lean, and slightly stooped in his old age. He had a magnificent white beard and his hair, too, was long and thick and put me in mind of a Sunday school book representation of Father Abraham. He was a great grandfather many times over and most of his family still lived nearby. His dignity was immense, and he had a deep commanding voice. One could not imagine him running away from the Devil himself. Yet the story was told that when he was a young boy there had been a fight after a dance when

he had had a few drinks. He and a good friend became embattled, and it ended with Bligh's sinking a knife into his erstwhile friend.

Frightened into soberness at the sight of his friend lying stretched on the ground, Bligh ran away to Kentucky. He stayed away twenty-five years and one day returned to face the community. The first to greet him, on his return, was his supposedly dead victim. The two men, now mature and each having a family, resumed their friendship.

17.

There *is a time to every purpose under the heaven*, as recorded in Ecclesiastes. I was increasingly aware that the time was coming when I would leave the homestead.

I thought about the reasons I had for coming to the mountains, about the experiences I had there, about my life before that.

It seemed a long time ago that I had sat at a table at the *Dome* in Paris with Grant Wood over a *demi-brun*, a dark beer, but it was less than five years. Wood

was involved with French Impressionism and he felt his results were unsuccessful. My own major interest then was drawing the people who slept under the Seine bridges at night and who were living in miserable ways that did not bear close examination. It had been a new and frightening experience for an American boy to find himself among people so poor and so without the opportunity of changing their status, or the hope of doing so. I saw them and I drew them with sympathy. I had no exactly defined social point of view. Here, in the southern mountains, I was drawing (and living among) the poor people of my own country.

My studio in the woods was completed. I had good light indoors, but much of my work, drawing and painting, I still did out of doors. I was remembering Grant Wood's words about getting away from the cities, and thinking that subject matter is only a part of a painting, yet is often the motivating force. Above and beyond it there are techniques that change, the materials with which one works, the scale, too—all these contribute.

Much of Cézanne that was beyond me as a student in Paris was now becoming clearer. The contemporaries, Picasso, Braque, and Chagall were more real to me, there in Paris, than the older painters I had come to study.

Now, living in the woods, my favorites among the older painters, Daumier and Rembrandt, were close to

me, probably because I had with me some excellent books bought in Paris. The Rembrandts in particular were etchings—not rare, but clear and well printed. The Daumiers were lithographs.

I was beginning to appraise and judge, not only the painters of the past but those of the present and mainly my own relationship to them and to my sur-

roundings and the time I was living in. Living in the woods gave me, as an individual, a chance to think about what was happening in a world less and less absorbed in man, more and more involved in technology.

In a natural environment, man does have some time to think his own thoughts and to read. Perhaps in the great city-and-country complexes tied together most

recently by broad highways and airways, man, as an animal, has been neglected. The violent rebellion, now and then flaring up, may be its effect. Perhaps life in the cities is so unbearable as to cause this.

Returning to the eighteenth-century life I lived in the mountains did not seem an answer either, but it did have this value for me: of making me more conscious of myself and my feelings about nature.

What was it that had sent me to the mountains to homestead?

Predecessors in my craft had chosen as I had: Winslow Homer had found a great fund of subject matter in the wilderness of the Adirondacks; Thomas Moran had journeyed to the Grand Tetons in Wyoming; Frederick Remington had left civilized New York for the Wild West. Beginning with Audubon, many American painters found in untamed nature an elemental force they hoped to capture in their work, and some did.

My own background in New York, San Francisco and Paris hardly did more than provide me with the technical equipment that was basic.

Coming to the mountains, I left behind me the modern ferment to which I was exposed in Paris. I looked around me, in the mountains, to observe and absorb a landscape and a people different from any I had had contact with.

I had many searching and black moments wondering if there was any use to this turning back the clock, and cutting myself off from the struggle in the world of art in New York. More than any physical hardship, this was the most difficult thought to face. I had hoped to discover a simpler life, one that would open to me a relationship between nature, art and myself. I, the painter, through this new close relationship with the natural world around me would be better able to paint it.

Once a year, John Ruskin, the English art critic, took the pupils in his university classes to work with

pick and shovel on the highway being rebuilt nearby, in order to point out to them the dignity of labor. I wonder if he succeeded in his high purpose and proved this to them. For myself, I never forgot the lesson that he provided. It made it easy for me to understand and respect a good craftsman in the woods. I found more in common with such a person than with a non-productive city-dweller.

I left the homestead in the mountains and went north. I did not intend to return. My experience in the wilderness seemed complete. The Homestead Law, so far as it concerned me, was now fulfilled to the satisfaction of the forester.

I filed my claim at the Land Office. In due time I received title to my homestead land, an original Land Deed signed by President Franklin D. Roosevelt.

In New York, the southern mountains seemed very far away. It was good to listen now to symphony music, to visit the great museums, to feel once more part of the struggle to produce art unencumbered by the daily physical effort of battling the elements and the obdurate soil.

One morning I received a letter from the Curator of Prints at the National Museum, the Smithsonian in Washington. I was invited to have a one-man show of all my graphic work.

Among other work I sent a portrait of Nolan emptying a jug of Mountain Dew, another of the Vander Tillary family on their porch, one of Uncle John's cabin, a portrait of Bev Murphy and his father, and one of Veona Tillary holding a rabbit. I sent some etchings, too.

One of the pictures that was sold out of that show was the one of Nolan drinking out of his jug, held in the crook of his arm. An army major purchased this.

The exhibition was well received, although one of the Washington Sunday newspapers said that among my work was "some ugly and undignified subject matter to exhibit in the Capitol Museum."

It is difficult to remember how isolated communities were, before radio and then television. On my last visit to the mountain country, in 1960, one saw the changes. The loneliest communities were now altered. Gas stations had appeared, the main road was paved, and driving was no longer a problem. A few bridges now crossed Cove Creek. The alteration extended to the mountain men themselves. At the Cove Valley Post Office where Zack's store once had a single hand gas-pump, there was now a fairly modern station. I found several men standing about. It was their lunch hour. They were road-workers and they were wearing yellow crash helmets. I ordered my tank filled, and a man moved over to the car window. I asked him where the

old road to Perryville was. He said, "It's still at the top of the hill. Aren't you the artist fellow who home-steaded there?" He then told me that he was one of the boys who had helped me build the cabin. I asked

for Joe Loomis and Marthy. He said that Joe had been in for gas the day before and lived in the same place some miles over the backroad. It was not possible to visit Joe and his wife since I was on my way to California and had not too much time.

I could not pass the homestead road without going up on it. It was not much of a road even now, but one could drive over it. The towering pines were still there, but as I approached the clearing where the house had stood, there was no visible sign of anyone having lived there. The woods were growing back, and a young pine stand covered my clearing. Not a stone of the chimney remained. A melancholy wind blew through the tops of the trees, announcing a quick summer storm. I got back into the car and left, I suppose, forever.